IMAGES
of America

HAMTRAMCK

SOUL OF A CITY

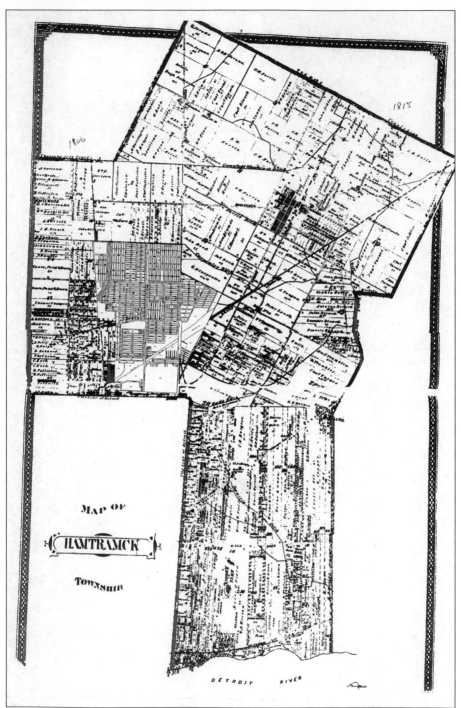

Once a sprawling area, Hamtramck Township had shrunk even by the time this map was made in 1876. At its greatest extent, Hamtramck extended from the Detroit River to Base Line (Eight Mile) and from Woodward through the Grosse Pointes. Over the decades, the township was annexed by Detroit, with the last annexation occurring in 1926, four years after the city of Hamtramck was formed. Present day Hamtramck is in the upper left portion.

IMAGES
of America

HAMTRAMCK
SOUL OF A CITY

Greg Kowalski

ARCADIA

Copyright © 2003 by Greg Kowalski.
ISBN 0-7385-2320-8

Published by Arcadia Publishing,
an imprint of Tempus Publishing, Inc.
3047 N. Lincoln Ave., Suite 410
Chicago, IL 60657

Printed in Great Britain.

Library of Congress Catalog Card Number: 2003100238

For all general information contact Arcadia Publishing at:
Telephone 843-853-2070
Fax 843-853-0044
E-Mail sales@arcadiapublishing.com

For customer service and orders:
Toll-Free 1-888-313-2665

Visit us on the internet at http://www.arcadiapublishing.com

CONTENTS

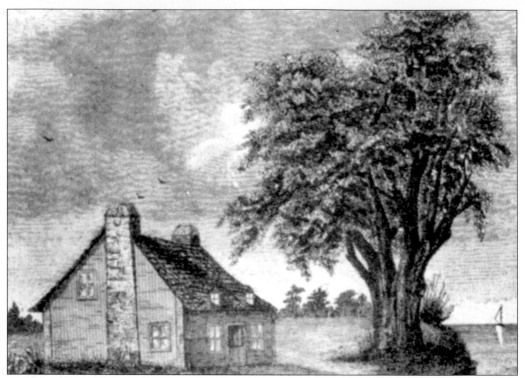

There are no portraits of John Francis Hamtramck, the man for whom the city is named. However, we do know what his house looked like. His log cabin was on Jefferson near Chene and lasted until 1890.

ACKNOWLEDGMENTS

A book of this nature relies on the input of many sources. Most of all, I would like to thank the Hamtramck Public Library and its director, Tamara Sochacka, for access to its resources and continued support. The archives of the Hamtramck Historical Commission were also a key source of photos and information. And I would like to thank my mother, Martha Violet Kowalski, for her unending encouragement. Finally I would like to thank the people of Hamtramck, for they are responsible for keeping Hamtramck a viable and vibrant community. They are a source of pride and inspiration to me.

INTRODUCTION

It is not the intent of this book to give a chronological history of Hamtramck. Rather it seeks to show in photos and captions the people and places that made this extraordinary city so special. And above all it is a story of people, for even the places are only meaningful in the context of the impact they had on the people.

Founded in 1798 as a township, Hamtramck was named after Col. John Francis Hamtramck, who distinguished himself in the Revolutionary War. Born a French-Canadian, he soon embraced the concept of liberty presented by the early Americans.

Throughout the 19th century, the township consisted of a collection of farms surrounding the city of Detroit. Originally, Hamtramck stretched from the Detroit River to Base Line (Eight Mile Road) and from Woodward through the Grosse Pointes. Over the decades, Detroit annexed Hamtramck a bit at a time.

In 1901, the Village of Hamtramck was formed, but it remained a largely rural town. It wasn't until 1910 that Hamtramck began to undergo a remarkable transformation. That year, Horace and John Dodge opened their auto factory on the southeast corner of the dusty village. At the time, the village had a population of about 3,500. Ten years later the population approached 48,000—all within an area of 2.1 square miles.

The reason for the phenomenal growth was the Dodge plant, which Hamtramckans affectionately christened Dodge Main. Almost all of the new residents were Polish immigrants, drawn to the jobs offered at Dodge Main.

The new Polish population soon learned the American political system and forced out of power the German saloon keepers who had traditionally controlled the town from their barrooms. From then on, Hamtramck became synonymous with Polish-American culture. By 1930, the city had a staggering population of 56,000 people, making it perhaps the most densely populated city in America. And more than 80 percent of the residents were of Polish descent.

In 1922 Hamtramck incorporated as a city to prevent any further annexations by Detroit, but while that ensured that Hamtramck would remain an independent community, it did nothing to solve the massive social problems that the huge immigrant influx brought. With few resources, Hamtramckans turned to innovation to deal with their challenges. School superintendent Maurice Keyworth was hired to manage the school district, and he soon developed landmark education programs that were adopted by school districts across the

country. He began special education classes as early as 1927 and brought doctors and nurses into the schools to treat health problems common among poor immigrant children. Keyworth also developed bilingual education programs and promoted adult education to move the children and their parents into mainstream American society.

While the schools made history, industry continued to have a major impact on the community. Dodge Main became a massive plant of more than 5 million square feet, and employed thousands. The often terrible working conditions at the plant spurred the establishment of labor unions, and in 1937, Dodge Main was the site of a major sit down strike. That strike was instrumental in forcing the auto manufacturers to accept the United Auto Workers as a legitimate bargaining agent of the workers.

Following World War II, Hamtramck was aging and facing a gradual loss of population. Many residents were looking for the wider lawns that were available in suburban communities. Most houses in Hamtramck were built between 1915 and 1930 on 30-foot-wide lots.

Homes in the suburbs were new and offered space for garages. Right through the 1980s, the city's population declined and urban blight became a serious threat.

But the people of Hamtramck would not surrender their city to any threat that time or change posed. By the 1990s, Hamtramck was on the rebound. In the 2000 census, Hamtramck recorded a 25 percent population increase—reversing a 70-year trend of decline. Housing values began shooting upward as more young professional people began to move into town. And a new wave of immigrants began arriving, this time from Bangladesh, the Middle East, India, Eastern Europe, and Arab countries. Now more than 30 languages are spoken in the schools, posing the school administrators with some of the same problems their grandparents faced.

Today, Hamtramck looks forward to a rich future. It has managed to weather all manner of political, social, financial, and cultural storms and remains a strong, viable community.

In the pages of this book, you will meet some of the many people who wove together the tapestry of Hamtramck. Individually, each photo is a small snapshot, but together they give a full portrait of a truly remarkable town.

One
BEGINNINGS

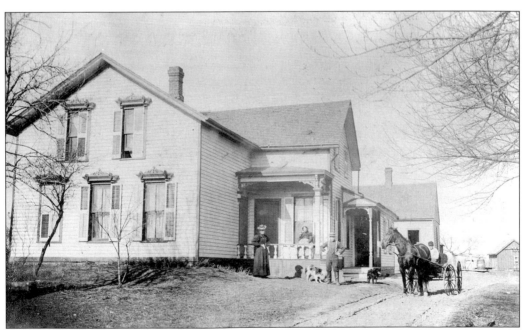

William Dickinson was one of Hamtramck's prominent early settlers. His farm was located at Comstock and Conant, near the present site of Dickinson School. The man standing by the porch is Robert Dickinson and the man in the buggy is William Dickinson, Robert's brother. At this time, around 1900, Hamtramck consisted mainly of farms. Creeks ran down Holbrook and Carpenter, and an early record describes how a long wooden fence ran along the west side of Jos. Campau, north of Holbrook, which is now part of the city's main shopping district.

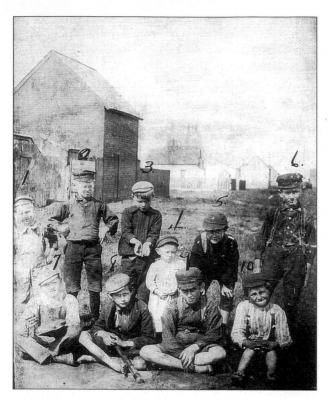

Looking like the Little Rascals, these kids gathered on Jos. Campau in 1905. They are Henry Breuhan, William Breuhan, Walter Kraft, Herman Breuhan, Walter Gustave Merique, Louis Breuhan, Elmer Ferguson, Louis Justin Merique, John Meissner, and Oscar Dewey Merique. (Photo courtesy of Kenneth Merique).

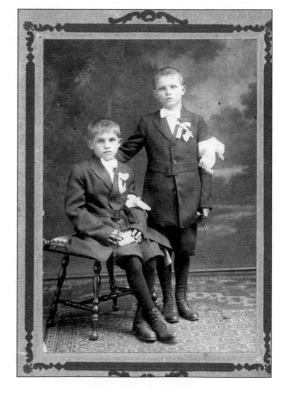

Matthew Mularski (left) and Walter Mularski posed for this photograph, probably their First Communion picture, in about 1917. The family lived on Goodson Street. First Communion was regarded as a significant occasion in the predominantly Catholic Polish families. (Photo courtesy of Carol Koss)

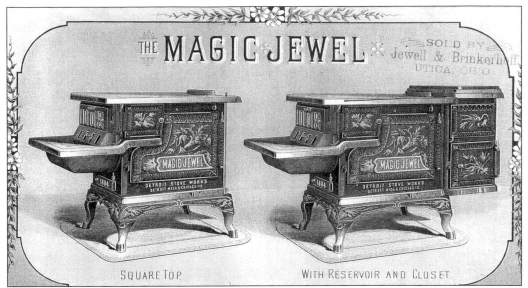

The Detroit Stove Works was actually located on the Detroit River in Hamtramck Township and was a major employer in the area, providing about 1,300 jobs. It manufactured 700 types of stoves, including the Magic Jewel model, which was popular for the home.

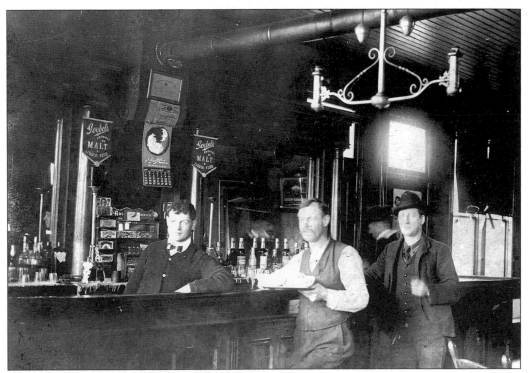

It's believed this is the bar belonging to A. Buhr, who was a prominent Hamtramckan around 1900. Buhr was one of the German saloon keepers who ran Hamtramck up until the Polish immigrant influx. In the years that immediately followed the opening of the Dodge Main factory in 1910, the Polish immigrants changed the town from a predominantly German farming community into an industrial Polish town.

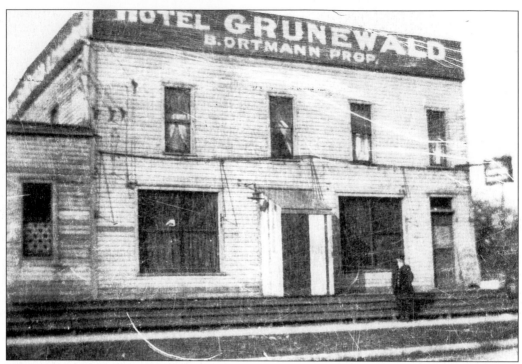

Hotel Gruenwald was an early town landmark, located on Jos. Campau near Smith Street, at the town's southern border. At this time, about 1900, Jos. Campau was still a dirt road and years away from becoming the main shopping district.

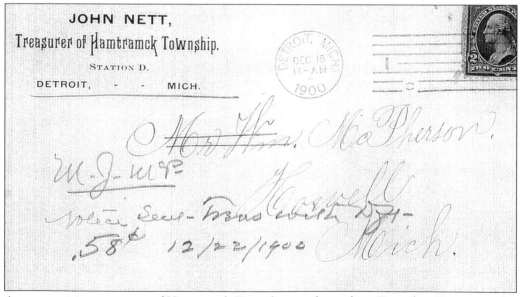

A rare surviving memento of Hamtramck Township is a letter from Township Treasurer John Nett, postmarked 1900.

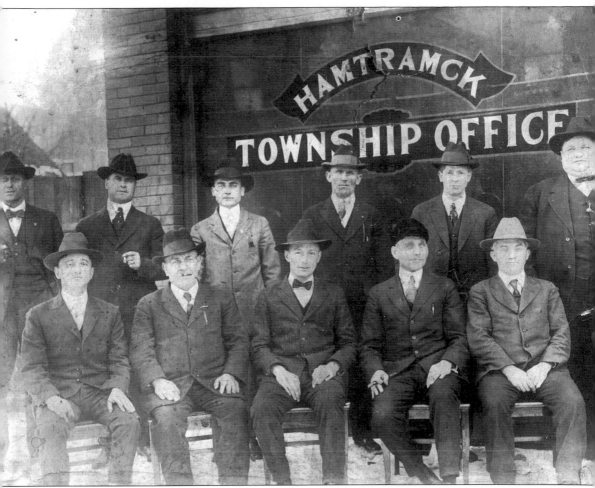

Almost no records of Hamtramck Township survive. We don't even know the names of these township officials. There were three Hamtramck Townships. The first was formed in 1798, when Hamtramck was created out of the wilderness. The second township was formed in 1818 and the third in 1827. The Village of Hamtramck was carved out of a portion of the township in 1901, but the last vestiges of the township remained until 1926 when it was absorbed by Detroit.

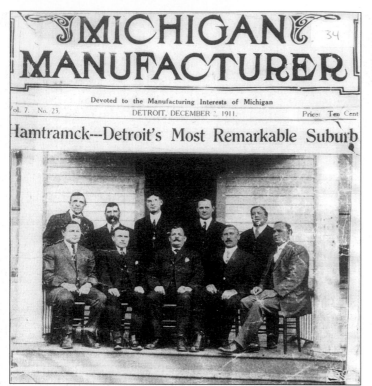

MICHIGAN MANUFACTURER

Devoted to the Manufacturing Interests of Michigan

Vol. 7. No. 23. DETROIT, DECEMBER 2, 1911. Price: Ten Cent

Hamtramck---Detroit's Most Remarkable Suburb

By 1911, when this photo was taken, Hamtramck had been a village for 10 years and was in the early stages of a population explosion that would increase its population from 3,500 to nearly 48,000 by 1920. All these people were packed into an area of about 2.1 square miles. These village officials would soon be overwhelmed by the immigrant population—and the problems they presented. Pictured from left to right are the following: (front row) Dr. A. Jones, Art Schriedft, Charles Geimer, John Schulties, and Anson Harris; (back row) G. William Zinow, Ed Russell, Charles Faber, and Henry Jacobs.

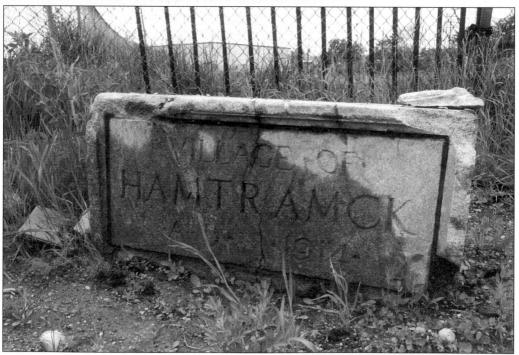

One of the last remnants of the Village of Hamtramck is this cornerstone from the old village hall, dating from 1914. Hamtramck never had a real municipal building. Town offices were scattered around the city. This building, at Jos. Campau and Grayling, also served as a fire and police station.

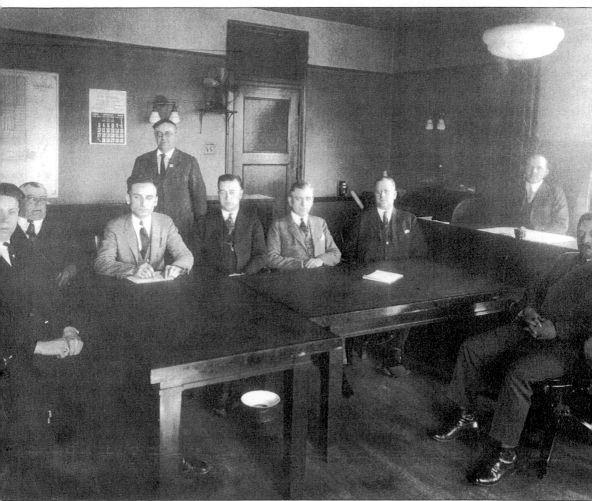

Hamtramck's first city officials were elected in 1922. They were, from left to right, Assistant City Clerk Arthur Rooks, Purchasing Clerk Henry Jacobs, City Clerk Joseph Mitchell, Court Clerk Walter Joliff, City Treasurer Walter Merique, Councilman Casimir Plagens, Councilman Andrew Templeton, Council President John Bucsko, and Councilman James L. Henderson. The village incorporated as a city in 1922 to avoid being annexed by Detroit, which by that time completely surrounded Hamtramck.

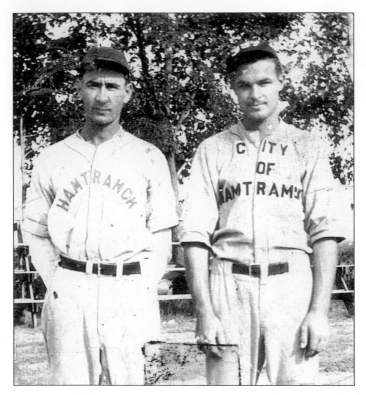

That's Walter Mularski of Goodson Street on the right. This early 1930s photo shows one of the city's early baseball teams. Mularski was so good he was offered a contract by the Detroit Tigers, but at that time they didn't pay enough to support a family, and Mularski turned them down. (Photo courtesy of Carol Koss.)

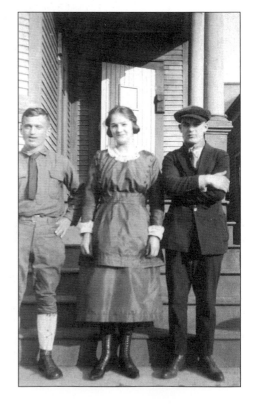

Jacob Kurczewski was wearing his World War I army uniform as he visited with friends around 1920, possibly on Goodson Street. (Photo courtesy of Carol Koss.)

Two

LEARNING FROM MAN AND GOD

From 1923 until 1935, Dr. Maurice R. Keyworth served as superintendent of Hamtramck Public Schools. Faced with the special needs of immigrant children, Keyworth instituted landmark bilingual education programs and pioneered special education classes and health care service for children. His influence spread across the country, and shortly before his untimely death in a car accident in 1935, Keyworth was named State Superintendent of Public Education.

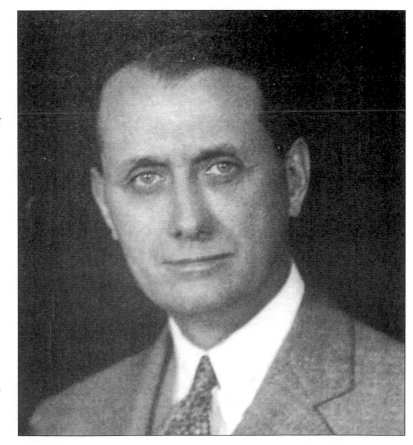

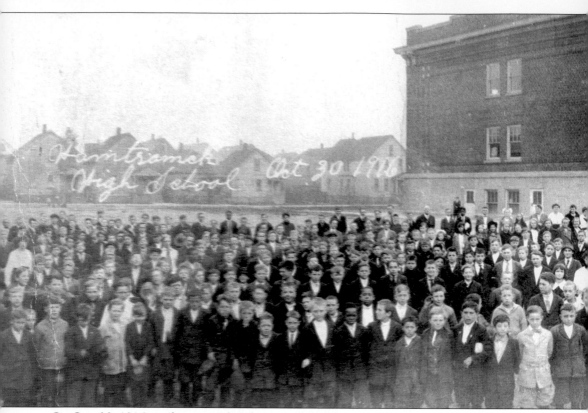

On Oct. 30, 1916, students posed at the recently constructed Hamtramck High School between Wyandotte and Hewitt streets. The new school was suddenly necessary due the city's

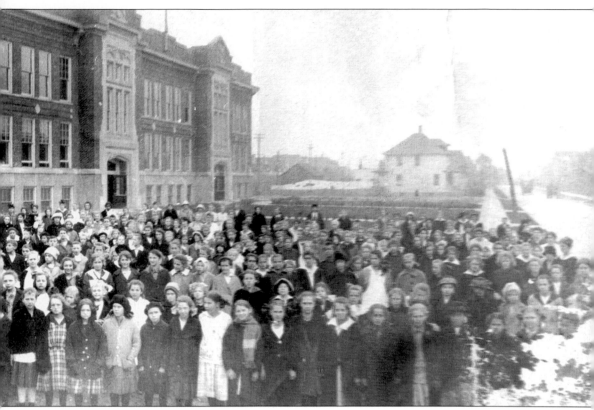

burgeoning population.

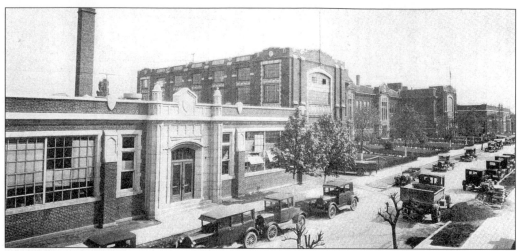

The Vocational School building (left) stood next to Hamtramck High School. At the far right is the Junior High School, which would be replaced by Copernicus Junior High in 1931.

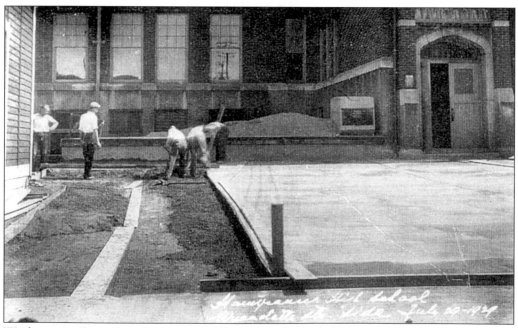

Workers install a parking lot on Wyandotte Street alongside Hamtramck High School in 1929. Until it was demolished in the early 1970s, Hamtramck High School was a centerpiece of the city's educational system.

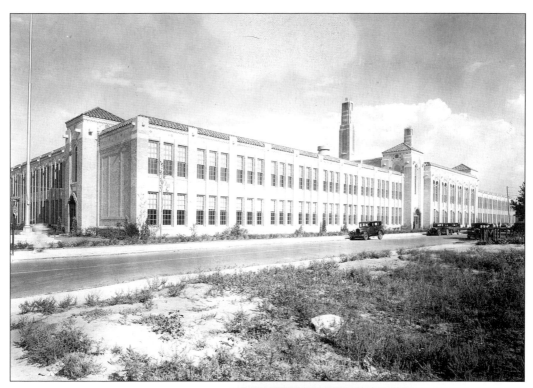

Copernicus Junior High School was hailed for its architecture and progressive programs when it opened in 1931. Today it remains in full use as Hamtramck High School.

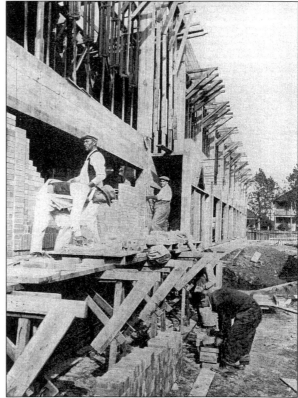

In all, 200 workers toiled to build Copernicus Junior High School. Its solid construction reflects the craftsmanship that was common then.

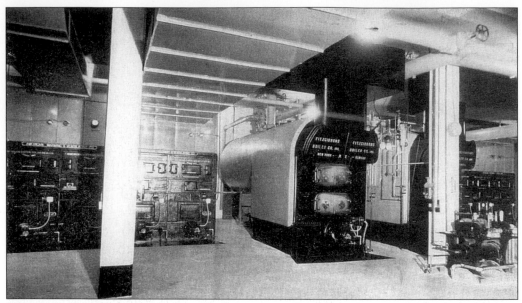

Like the interior of a battleship, Copernicus was heated by massive boilers. "Comfort is necessary to good instruction. Efficiency is necessary to good finance," a school bulletin advised parents.

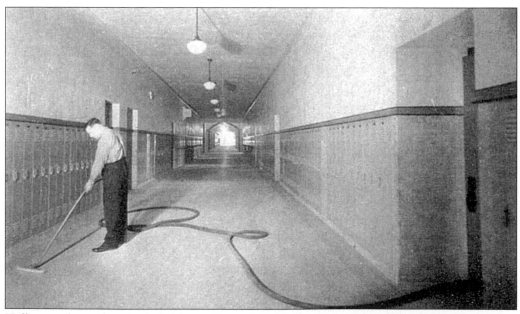

Halls were kept gleamingly bright at Copernicus by the janitorial staff. Little has changed in these halls, which are still traveled by students today.

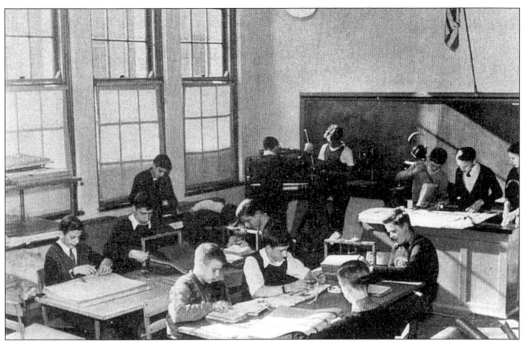

Copernicus boasted the latest school technology of its time. Students had a studio to broadcast messages and music throughout the building.

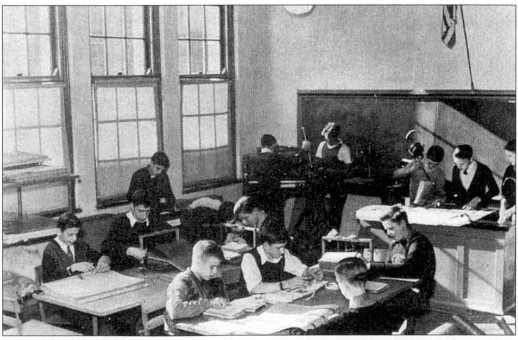

Curriculum in the 1930s included some courses that probably wouldn't find much favor today. These Copernicus students are in a bookbinding class. They not only learned a trade, the school claimed, but they also helped the schools save money by repairing books.

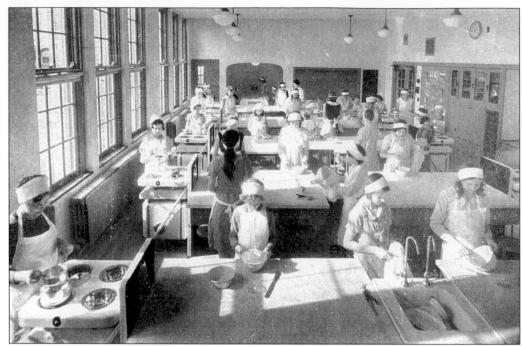
The Cooking Room at Copernicus School was equipped with "Electro-Chef Cooking Ranges."

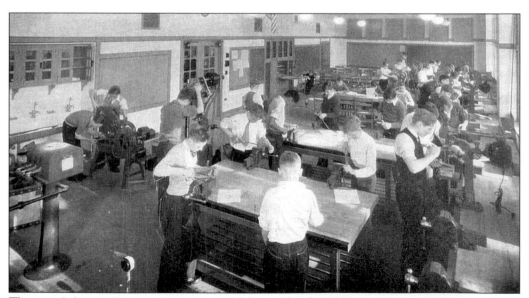
The metal shop at Copernicus was state-of-the-art for the 1930s.

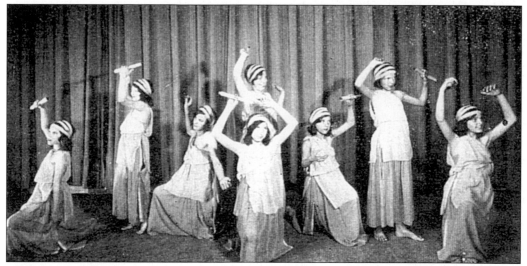

Then (c. 1930) as today, kids participated in various programs. These elementary students are demonstrating their dancing skills in a program called the "Elementary School Correlated Project Play."

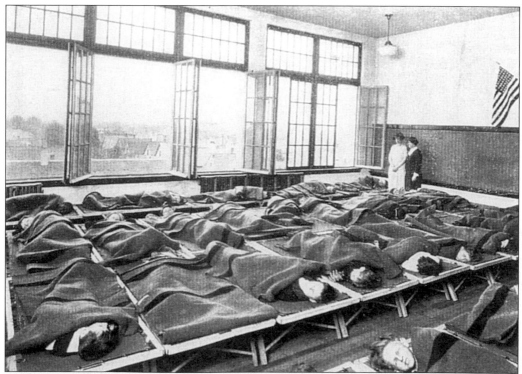

Sunshine and fresh air figured into the education process. "Sickly and run down" children were treated specially in the open-air rooms at Pulaski School.

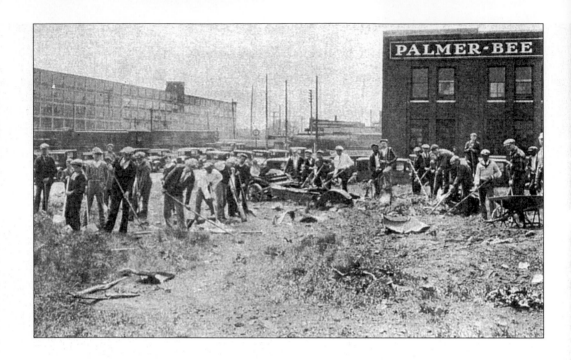

These rare shots show students from Whitney School cleaning up rubbish in a lot at Dyar and Poland streets in about 1930. This site was obliterated in the 1960s by the I-75 expressway that cut through the west side of town.

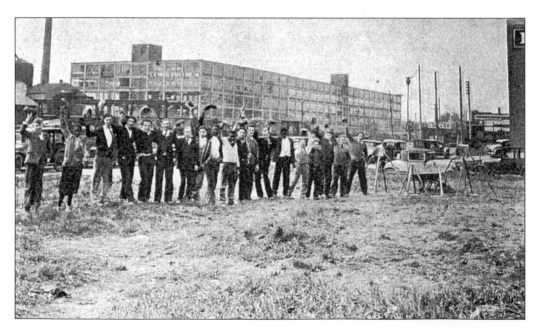

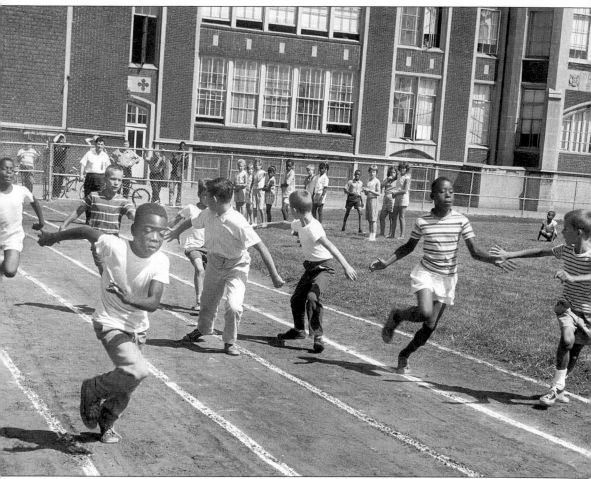

The tradition of keeping kids healthy continued long after Dr. Keyworth's death. At Pilsudski School, these kids run a relay race in 1963. The school was originally called Playfair School but was renamed Pilsudski School in 1935 in honor of Polish World War I hero Josef Pilsudski. The change reflected the overwhelming Polish presence in Hamtramck.

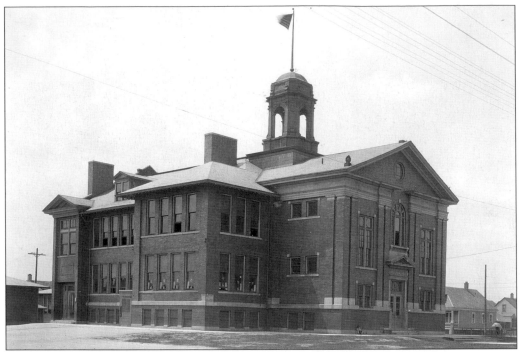

Carpenter School was one of the first school buildings to be closed. It shut its doors in 1935 and the site was converted into a park. In the 1970s, the land was sold to North Detroit General Hospital and converted into a clinic and parking structure. Note the child sitting near the front door at right.

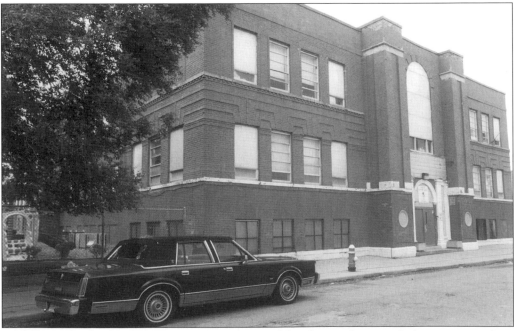

Holbrook Elementary school opened in 1896 and has been educating kids ever since. It is perhaps the oldest operating school in the state.

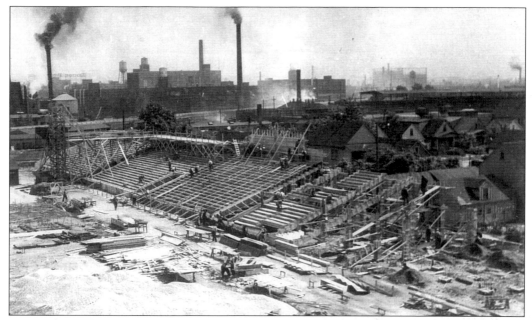

Keyworth Stadium was built in 1936 through the Works Project Administration program. Located next to Pilsudski School, it was dedicated by President Franklin Roosevelt in October 1936.

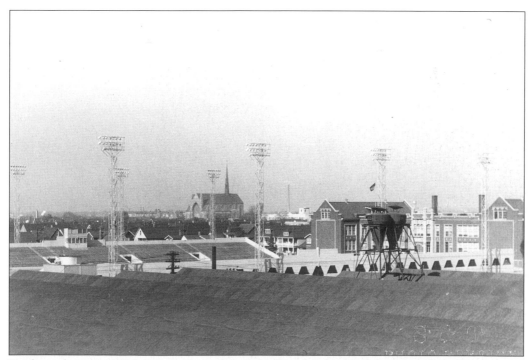

Bright and new in 1936, Keyworth Stadium became a focal point for recreational activities and continues to be used by schools across the metro area. In the background is one of Hamtramck's most prominent landmarks, St. Florian Church.

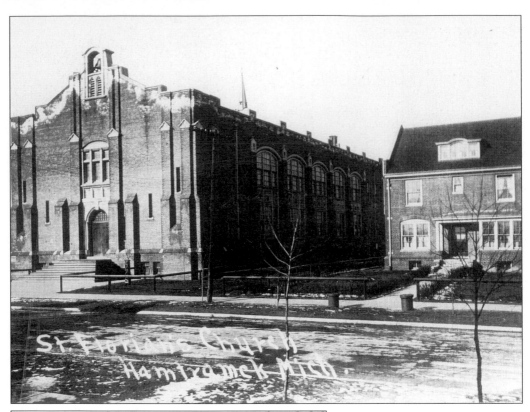

St. Florian parish was established in 1907 to serve the growing Polish community. A grade school and high school were soon built and at their peak enrolled 2,500 students.

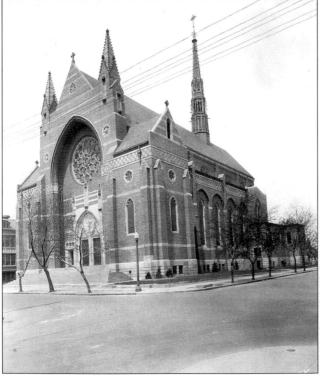

Built at a cost of $500,000, St. Florian Church was designed by world-renowned architect Ralph Adams Cram, who was a key proponent of Gothic architecture in America. The steeple rises 200 feet and is visible from two miles away. The style is modified English Gothic.

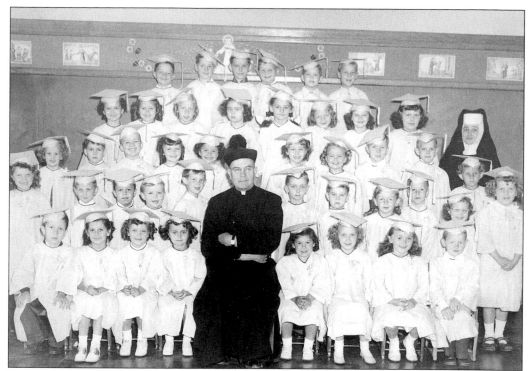

In caps and gowns, the kindergarten class of Our Lady Queen of Apostles School poses for a class photo in 1952. Queen of Apostles, St. Florian, and St. Ladislaus parishes all operated Roman Catholic schools. Immaculate Conception Ukrainian Catholic Church, an Eastern Rite church, provided schooling for Ukrainian Catholic children.

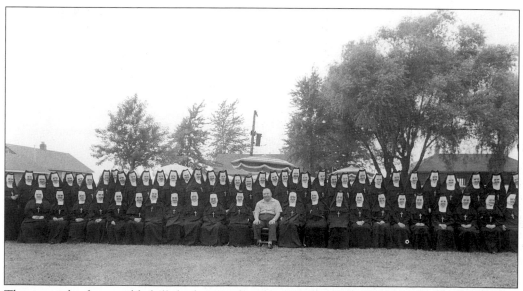

This is a sight that would chill the hearts of students at the city's Catholic schools—a phalanx of nuns stretches out behind Mayor Albert Zak. The nuns were strict disciplinarians.

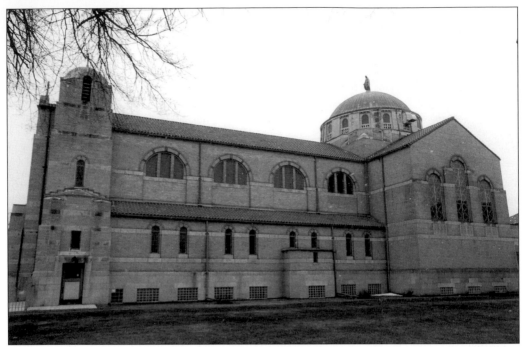

Built just prior to the outbreak of World War II, Immaculate Conception Ukrainian Catholic Church was patterned after the Hagia Sophia in Istanbul, with its distinctive domes.

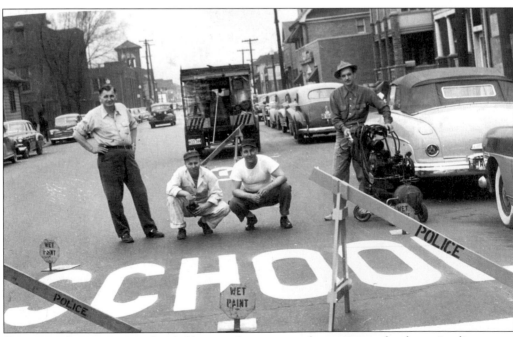

Care was taken to protect the children, as these city workers paint a school crossing line across Caniff Avenue c. 1950. St. Ladislaus Church and School are at left.

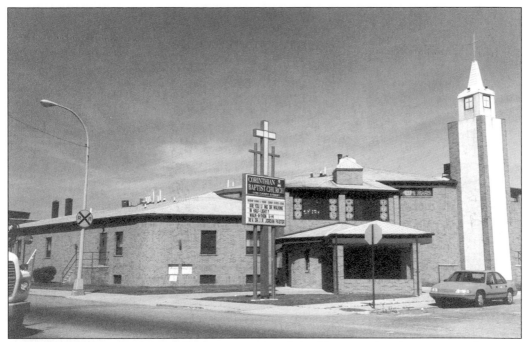

Corinthian Baptist Church has been a mainstay of the Hamtramck religious scene for more than 80 years. Corinthian is the most prominent African-American church in the city.

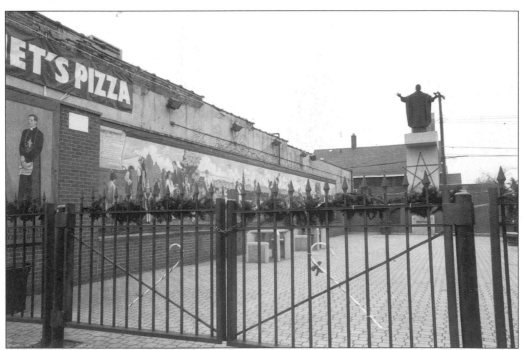

Religious spirit remains strong today—even in some incongruous ways. The "Pope Park" at Belmont and Jos. Campau was built to honor Pope John Paul II, who has family ties to the city. His cousin was a former councilman. A mural of a Polish scene adorns the wall of the park, as does a sign for the adjoining pizza parlor.

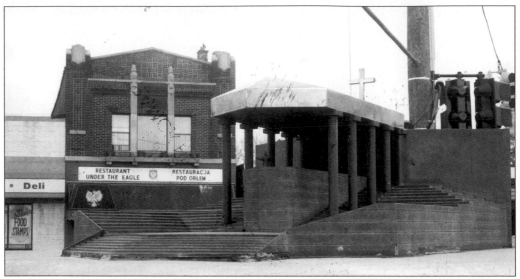

Pope John Paul II's visit to Hamtramck in 1987 was commemorated with a miniature re-creation of the stage from which he addressed the crowd at the Hamtramck Town Center. Across Jos. Campau is the Under the Eagle Polish restaurant.

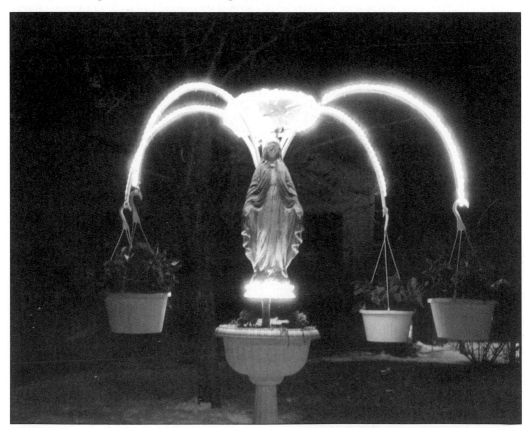

It's not unusual to find figures of the Madonna in yards and in front of houses around Hamtramck. Perhaps the most distinctive is the lighted figure that stands next to a house on Moran Street.

Three
PERSONALITIES

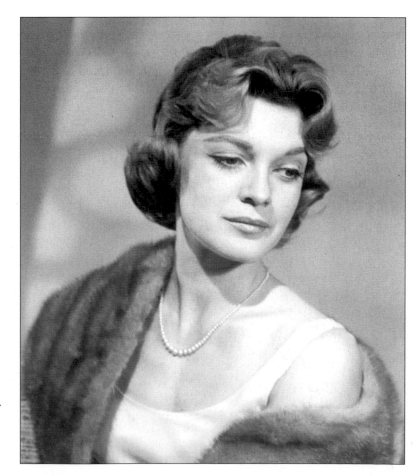

Hamtramckan Gail Kobe achieved success in Hollywood, appearing in dozens of TV shows, such as *Outer Limits* and *Perry Mason* and in such movies as *The Ten Commandments*. She was also a successful producer or many daytime soap operas.

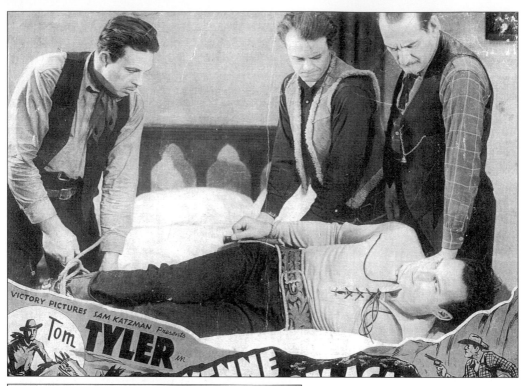

VICTORY PICTURES SAM KATZMAN Presents
Tom **TYLER** in

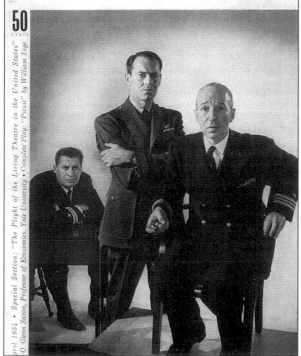

THEATRE ARTS

50 CENTS

April 1954 • Special Section: "The Plight of the Living Theatre in the United States" • O. Glenn Saxon, Professor of Economics, Yale University • Complete Play: "Picnic" by William Inge

You may never have heard of the movie *Cheyenne Rides Again* or its star, Tom Tyler, but the one-time Hamtramckan became the top paid Western star in Hollywood in 1940. Tyler also was known to millions of kids as "Captain Marvel" in movie serials in the 1930s. A former body builder and auto plant employee, Tyler died of heart failure in 1954 at St. Francis Hospital in Hamtramck, after returning to the area when his health began to fail. He was 50 years old.

John Hodiak graduated from Hamtramck High School in 1932. The rugged young actor found success on Broadway and starred in such major films as Alfred Hitchcock's *Lifeboat*. Like Tom Tyler, Hodiak also died too young, in 1955, of a heart attack. *Theatre Arts* magazine profiled the 1954 production of *The Caine Mutiny Court Martial* starring Hodiak (left), Henry Fonda, and Lloyd Nolan.

Sixteen-year-old Hattie Lukasik, "a 5-foot-5-inch blonde" was named Miss 16 of Detroit in a contest sponsored by TV station Channel 50 in 1967. A Hamtramckan, Lukasik was a junior at Hamtramck High School at the time. She is now Hattie Killenberg, lives in Harper Woods, and still has the TV set she won as part of her prizes, as outlined in the accompanying press release.

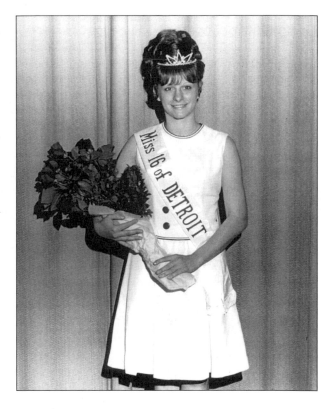

WKBD-TV 50
DETROIT
KAISER BROADCASTING
904-359 · SOUTHFIELD, MI 45075 · 313 444-8800

NEWS RELEASE

PLEASE HOLD FOR RELEASE ON
Saturday, June 10, 1967
After 6:00 p.m.

HAMTRAMCK GIRL NAMED "MISS 16 OF DETROIT"

Hattie Lukasik, 16, daughter of Mr. and Mrs. John Lukasik of 3032 Goodson, Hamtramck, Michigan, has been named "Miss 16 of Detroit" in a contest sponsored by Channel 50's HY LIT SHOW and 16 Magazine. Her prizes included a TV set, a wrist watch, a record player and others.

Hattie, a 5 foot 5 inch blond, is a Junior at Hamtramck High School. Her picture will appear in the October issue of 16 Magazine, where she will compete with other winners from all over the country for the title "Miss 16 of America", which will include the awarding of a college scholarship, a Hollywood screen test and other prizes.

The announcement of winners was made on THE HY LIT TV SHOW, Saturday, June 10th at six p.m. on WKBD-TV, Channel 50, Detroit. Among the other local girls honored were:

1st Runner-up	Brenda Grant 3018 Clairmount Detroit, Michigan
2nd Runner-up	Darlene Stalo 15644 Edgewood Drive Livonia, Michigan
3rd Runner-up	Judy K. Craig 2814 Bragg Road Deerfield, Michigan

Miss Lukasik and runners-up were selected from hundreds of pictures submitted.

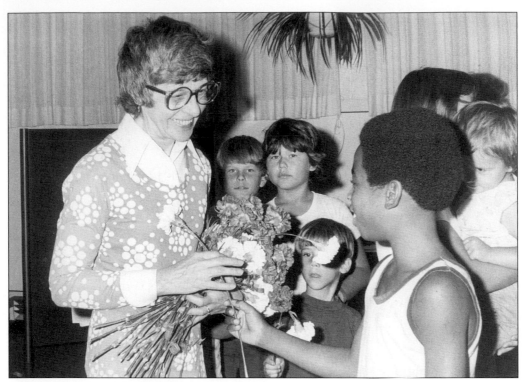

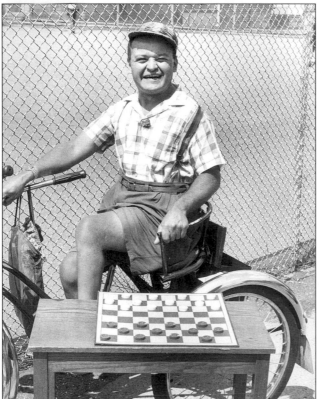

Bea Adamski was a key figure at the Hamtramck Public Library for 40 years. She was known to thousands for her total dedication to the library, and was instrumental in making the construction of the library building on Caniff a reality. Upon her retirement in 1977, young library patrons presented her with flowers. She died in 2002 and was memorialized at a special banquet at the Holbrook Café. Among those sending their regards was actress Gail Kobe, who was her sister.

A familiar face for many years, Richard Gish proclaimed himself "Hamtramck's Checker Champion," and no one ever doubted him. He carried his checker board as he rode his three-wheeled bike to parks and playgrounds across Hamtramck, taking on all challengers. He usually won.

STATEMENT.

McGraw Bro's.

SAMPLE ROOM

96 Riopelle St. Phone. M. 4212 L.

D. J. P. J.

Detroit Mich. 190

Patrick "Paddy" McGraw (right) was one of Hamtramck's most colorful characters. During Prohibition he ran what was considered one of the finest brothels in the Midwest. Men would come from as far as Toledo and Flint to visit the establishment, which was conveniently located on the railroad tracks. The card, with its reference to a "sample room," is from one of McGraw's legitimate businesses.

Politicians have traditionally played hardball in Hamtramck. *The Hamtramck News* was a thinly disguised political publication put out by Joseph Lewandowski, chief rival of Mayor Rudolph Tenerowicz in 1938. Tenerowicz was a charismatic doctor beloved by many Hamtramckans, and survived a corruption conviction and stint in prison only to be elected a U.S. Congressman. Tenerowicz served as mayor from 1928 until 1931 and again from 1936 until 1939. Lewandowski served one term as mayor, 1934 to 1936.

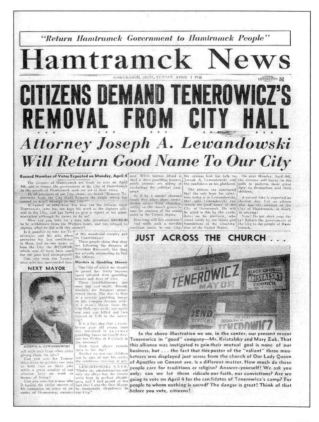

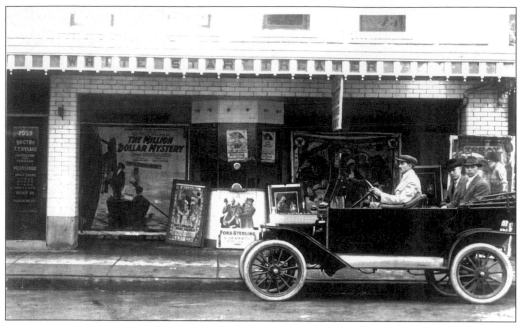

Dr. T.T. Dysarz pulls up in front of his office during the 1920s. Dr. Dysarz was a prominent Hamtramckan, and served on the school board. Dr. Dysarz is driving. The man with the dark hat in the back seat is his cousin, John Dysarz.

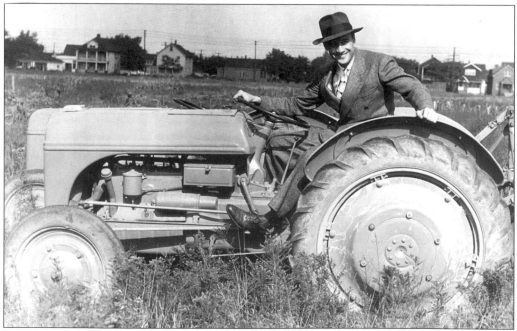

City Councilman John Wojtylo was one of the most flamboyant of all Hamtramck politicians. In the 1940s and 1950s, he led fiery campaigns against corruption and ran for mayor several times—without success. During World War II he rode a tractor (in a suit, no less) across a vacant lot on the city's northwest side to encourage residents to plant Victory Gardens and aid the war effort. Wojtylo was a bitter opponent of Mayor Al Zak.

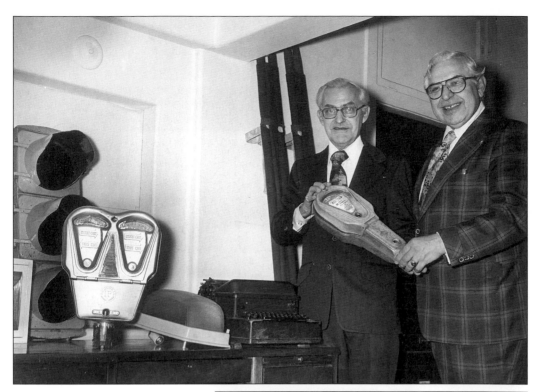

Two of Hamtramck's veteran politicians were William Kozerski (left) and Walter Gajewski. Kozerski was the only city official ever to hold all four major elected offices: mayor, councilman, treasurer, and clerk (honorary). Gajewski served as city clerk for 30 years, from 1950 to 1980, and was one of the longest-serving politicians in America.

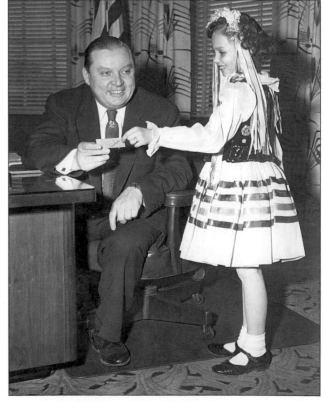

Mayor Albert Zak was one of the most popular mayors in the city's history. He guided the city through its best years, in the 1950s. Zak never missed a photo opportunity. In April of 1954, he bought a ticket from Judy Kozak, 9, to publicize the Polish Women's Alliance Council 20 dance recital at Copernicus School.

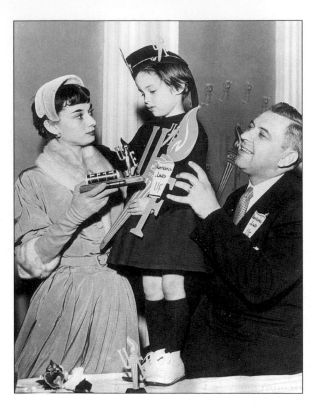

Oscar-winning actress Audrey Hepburn paid a visit to Hamtramck in 1954 to present an "Oscar" to Kathy Valewski. The award was for Hamtramck's participation in the annual United Foundation drive to raise money for charitable causes. With them is City Clerk Walter Gajewski.

November 1973 was a key election date in Hamtramck. Incumbent Mayor Raymond Wojtowicz was facing a challenge by Albert Zak, a former mayor who left city politics for 10 years to work in a county post. He returned as Hamtramck was wrestling with a severe financial crisis, and would go on to win this election, but die of a heart attack a year later. The ballot also features some major political figures, such as long-time Clerk Walter Gajewski and Robert Kozaren, who would become the city's longest serving mayor seven years later. Virtually ever other person on the ballot had long connections to Hamtramck's political scene.

OFFICIAL BALLOT
OF THE
CITY OF HAMTRAMCK

Nº 2

Candidates for election for City offices of the City of Hamtramck at the City Biennial Election held on Tuesday, the 6th day of November, 1973

INSTRUCTIONS

Make a cross [X] in the square to the left of not more than the number of names for said office as may be indicated under the title of said office.

Before leaving the booth, fold the ballot so that the face of the ballot is not exposed and so that the numbered corner is visible.

FOR MAYOR (Vote for Not More Than One)	FOR COUNCILMEN (Vote for Not More Than Five)	FOR MUNICIPAL JUDGE (Vote for Not More Than One)
RAYMOND J. WOJTOWICZ	WILLIAM V. KOZERSKI	STEVEN G. DANIELSON
ALBERT J. ZAK	JOHN KRYCZKOWSKI	CHARLES W. KOTULSKI MUNICIPAL JUDGE
	MITCHELL M. LEWANDOWSKI	
FOR CITY CLERK (Vote for Not More Than One)	JOHN PITLOSH	
	EUGENE L. PLUTO	FOR CONSTABLES (Vote for Not More Than Two)
WALTER J. GAJEWSKI	ALFRED ULMAN	
ROBERT W. KOZAREN	LORETTA URBANSKI	GEORGE J. OLEKSIAK
	VASIL VASILEFF	FRED WALDOWSKI, JR.
	ESTELLE JAWORSKI	JOHN DEMSKI
FOR CITY TREASURER (Vote for Not More Than One)	HELEN JUSTEWICZ	CARL KARPINSKI
EDWARD KONDRAT		
MITCHELL B. KOZAK		

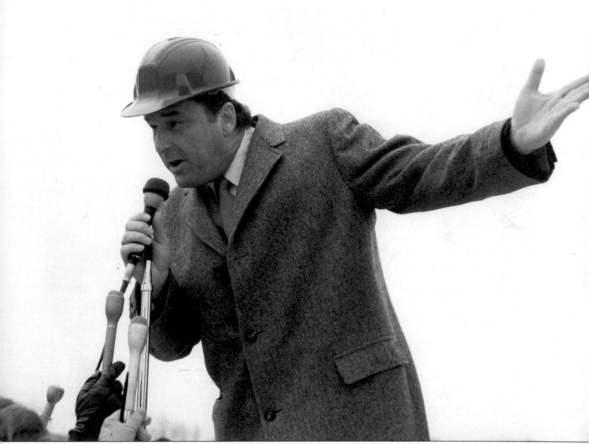

Robert Kozaren reaches toward the future at the ground-breaking for the General Motors Poletown plant in 1981. Kozaren had been elected mayor a little more than a year earlier. Hamtramck was in desperate financial shape at the time because of the closing of the Chrysler Dodge Main plant, which stripped the city of much of its tax revenue. Kozaren was instrumental in bringing the GM plant—and its tax revenue—to Hamtramck. (Photo courtesy of *The Citizen.*)

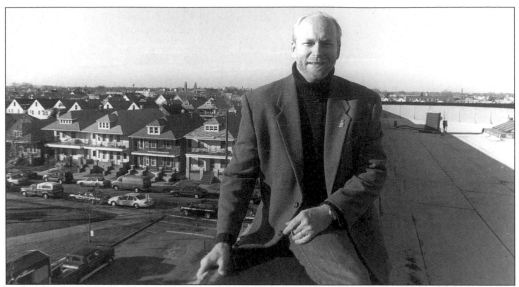

After 20 years in office, Mayor Robert Kozaren was challenged by a new group of Hamtramckans who felt the city was stagnating and needed fresh blood. They found it in Gary Zych, who narrowly defeated Kozaren in 1997. Zych faced a city that was bitterly politically divided, but he struggled to invigorate the town with new commissions and boards and appealed to the new immigrant population of Arabs, Eastern Europeans, Bangladeshi, Indian people, and numerous other ethnic groups. (Photo courtesy of *The Citizen*.)

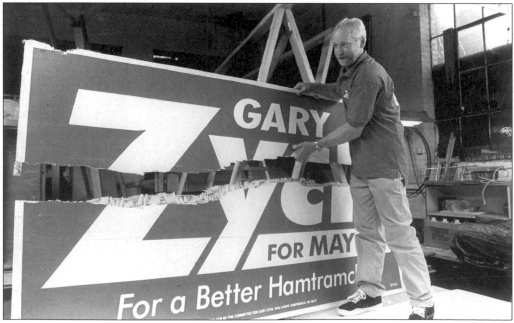

The political hardball games continue. Current Mayor Gary Zych stands with one of his signs that was vandalized by a political opponent in 1999. Some Hamtramckans maintained strong loyalty to former Mayor Robert Kozaren, and others objected to Zych's "let's just do it" style that often bypassed the city council. But he has played politics just as hard as anyone who opposed him. (Photo courtesy of *The Citizen*.)

44

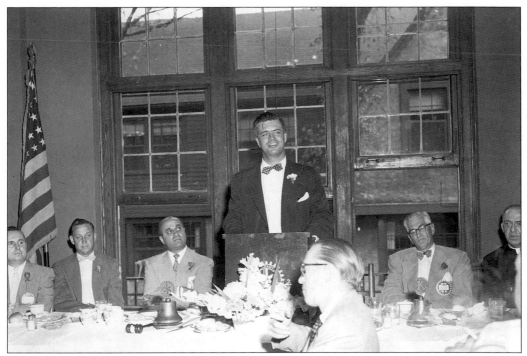

Hamtramck's political influence has extended far beyond its limited borders. During the 1930s, it wasn't unusual for Hamtramck to have over an 80 percent voter turnout for an election. And support for Democrats was solid. Democratic Governor G. Mennen Williams had a fondness for Hamtramck and visited several times in the 1950s. To Williams' immediate right is prominent Hamtramck businessman Woodrow W. Woody—a diehard Republican.

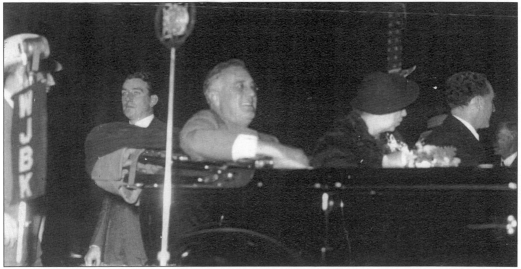

The Parade of Presidents began on Oct. 15, 1936, when Franklin Roosevelt came to Hamtramck to dedicate Keyworth Stadium, which was built through the government Works Project Administration. "A great stadium of this kind appeals to me as one of the things that will last for many years and contribute towards enjoyment and recreation not only for us older people but for the younger generation as well," Mr. Roosevelt said.

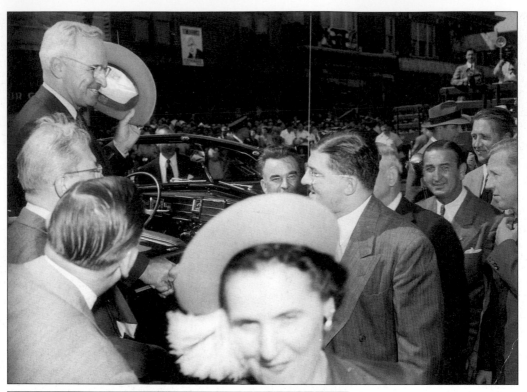

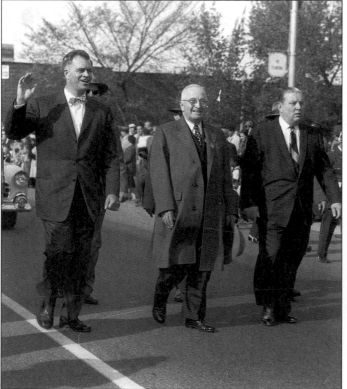

On Oct. 12, 1958, President Harry S. Truman received a massive welcome as he visited Hamtramck. Long a Democratic stronghold, Hamtramck had a great appreciation for Democrats since the New Deal days of President Roosevelt. In the foreground is Councilwoman Julia Rooks, who was known for her memorable hats, as well as 20 years of service to the city.

President Truman received such a warm reception during his visit on Oct. 12, 1958, that he got out of his car and walked to Veterans Memorial Park. On Mr. Truman's right is Governor G. Mennen Williams. At his left is Mayor Albert Zak.

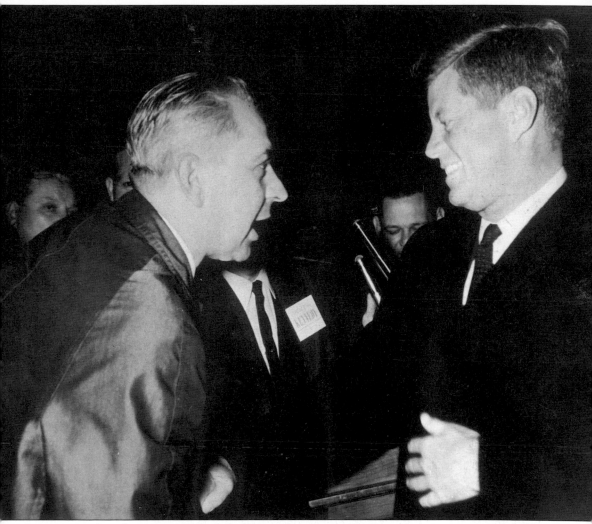

Just prior to his election in 1960, John Kennedy came to Hamtramck on a campaign swing. Here he is greeted by Clerk Walter Gajewski. "As long as you live, Poland lives," Kennedy told a crowd of 5,000 at Keyworth Stadium.

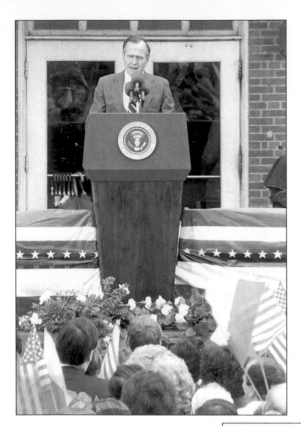

In March 1989, President George Bush came to Hamtramck to announce a package of economic aid for Poland. He spoke on the steps of City Hall. (Photo courtesy of *The Citizen*.)

THE WHITE HOUSE
WASHINGTON

February 10, 1999

Warm greetings to the citizens of Hamtramck and people throughout metropolitan Detroit as you celebrate Paczki Day.

Paczki Day has its origins in the rich religious traditions of Poland. Families prepared for the rigors of Lenten fasting by making and eating the delicious pastries they called "paczki" before the onset of Ash Wednesday. Our nation has been continually renewed and enriched by such traditions and by the many different people who have chosen to come here over the generations. Each person brings a part of his or her own heritage, which over time becomes part of our common heritage and reminds us of who we are and of what we have to share with others.

Polish Americans can be proud of their roots and of the many contributions the Polish people and culture have made to our national life. From business to the arts, from government to academia, Polish Americans have played an important part in advancing the prosperity that our country enjoys today.

As people throughout Metro Detroit observe Paczki Day, let us all remember to cherish the diversity that is America's greatest strength and to celebrate the spirit of community that binds us together as one nation.

Best wishes for a wonderful celebration.

Bill Clinton

Smacznego!

"Warm greetings to the citizens of Hamtramck…as you celebrate Paczki Day," President Bill Clinton wrote in February 1999. Paczki, pronounced "poonch-ki," are traditional fruit- or custard-filled doughnuts served just before the beginning of Lent.

World War II hit Hamtramck hard because so many of the Polish residents had family members in Poland. Hamtramck responded to the call to duty as hundreds of young men and women joined the service or were drafted. Their names were placed on a board at the municipal offices, which is viewed by Mayor Walter Kanar in this July 1941 photo. With him is drum major Charles Maloney of the American Legion Bushway Post.

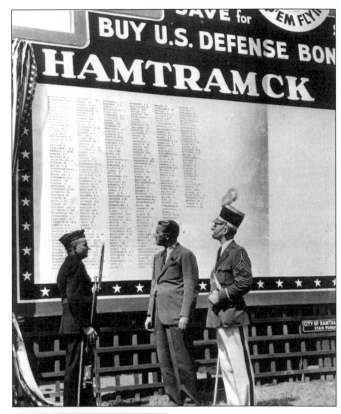

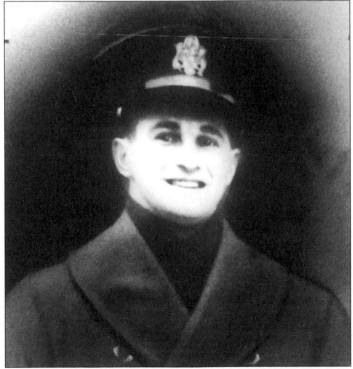

Lt. Raymond Zussman was awarded a Congressional Medal of Honor for giving his life in the war. He nearly single-handedly liberated the town of Noroy Le Bourg in France before he was killed in action in September 1944. The park in front of City Hall is named in his honor. (Photo courtesy of Milton Zussman.)

In an era when African-Americans and whites didn't mix much, Dr. Haley Bell had patients of all races at his dental offices on Jos. Campau. He was loved by many Hamtramckans, black and white. Active in many areas, Dr. Bell founded WCHB-AM and WCHD-FM radio stations in the 1950s.

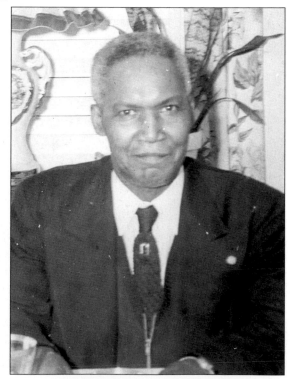

Ordine Tolliver was another distinguished African-American who was well-known to many Hamtramckans. He was active in many organizations.

For many Hamtramckans, the most distinguished guest the city ever welcomed was Pope John Paul II, who visited the city in September 1987. The pope drove down Jos. Campau in his bulletproof "Popemobile" before greeting people and speaking at the construction site of the Hamtramck Town Center shopping plaza at Holbrook and Jos. Campau.

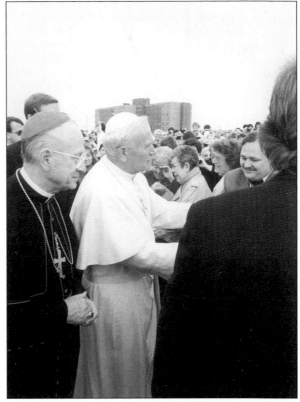

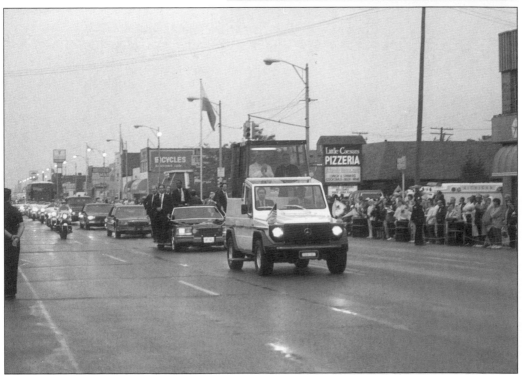

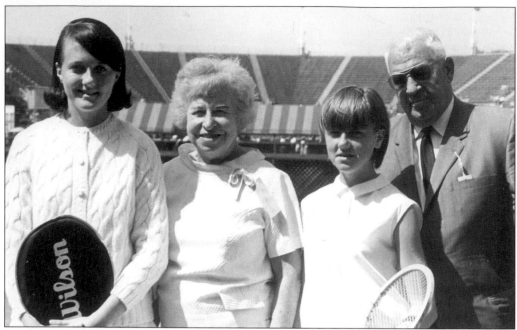

Jean Hoxie was a near-legendary tennis teacher who trained so many kids she was profiled in *Reader's Digest* magazine in September 1948. One of her greatest pupils was Jane "Peaches" Bartkowicz (left) who won the Junior Girls World Championship in 1964 at age 15. To Hoxie's left is Peaches' sister, Christine "Plums" Bartkowicz, and Jean's husband, Jerry.

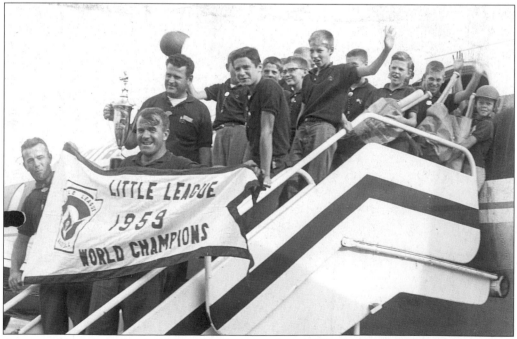

A group of boys brought world fame to Hamtramck in 1959 when they won the Little League World Championship. The team defeated Auburn, California, 12–2 to win the title. The champs received an enthusiastic welcome at the airport when they returned home.

Key players on the championship Little League team were Art "Pinky" Deras (left) and Greg Pniewski.

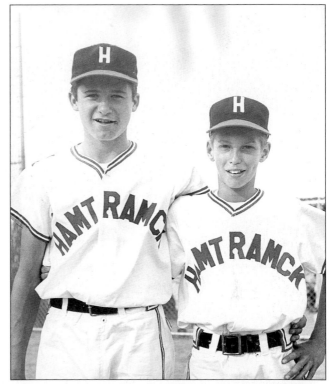

In 1961, the Hamtramck Pony League players showed they had winning style as well, as they won the Pony League World Series. Presiding over an awards presentation is Mayor Albert Zak.

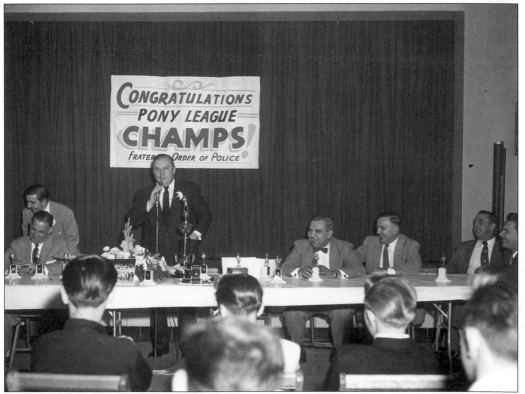

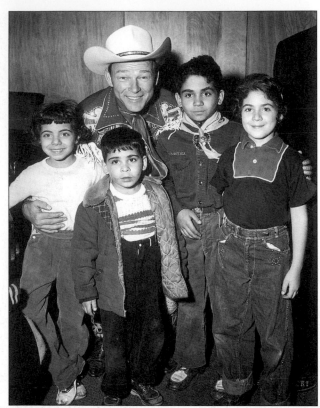

A group of wide-eyed youngsters are embraced by cowboy Roy Rogers, who was grand marshal at the Dodge Days parade in November 1954. The week-long event was held in conjunction with the Dodge Main plant to introduce the new 1955 Dodge models.

Lee Barecki, 21, was named Queen of Hamtramck to preside over the Dodge Days celebration in November 1954. From left are Mayor Albert Zak, Governor G. Mennen Williams, Queen Barecki, and Roy Rogers.

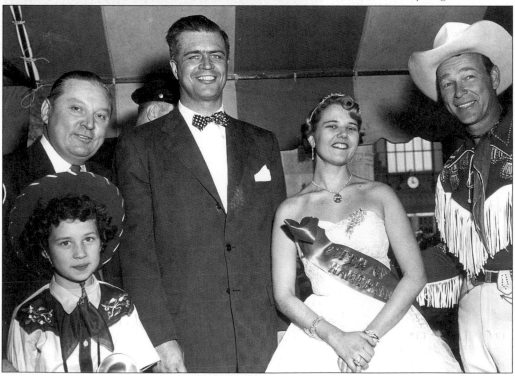

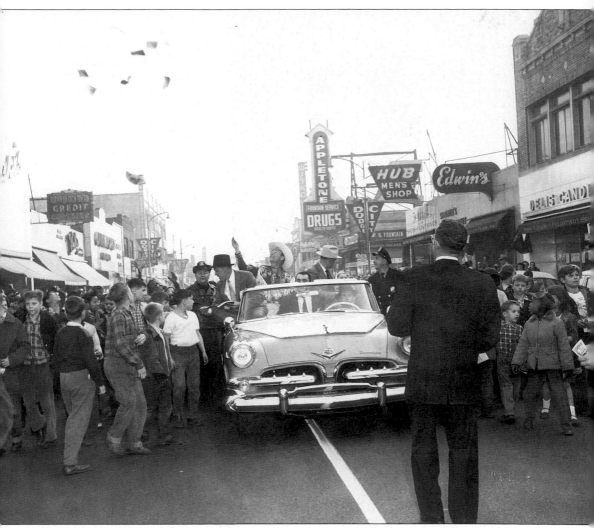

Crowds pressed up against the Dodge carrying Roy Rogers as he led the big Dodge Days Parade down Jos. Campau.

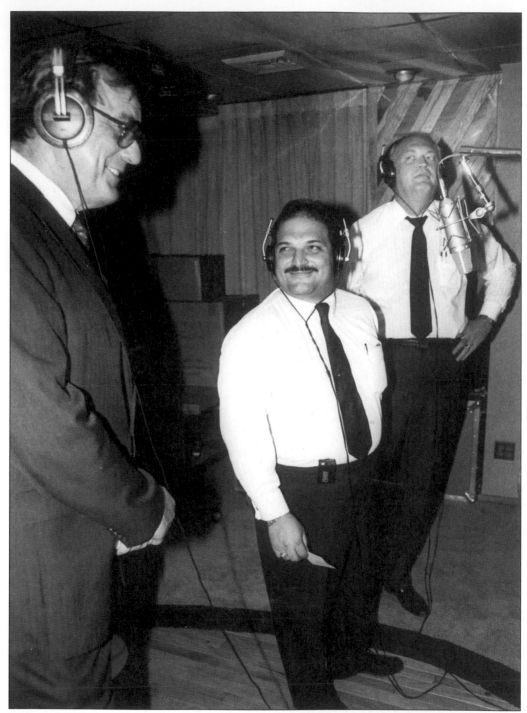

Ending this section on a high note are Mayor Robert Kozaren (left), Dearborn Mayor Michael Guido (center), and Warren Mayor Ron Bonkowski (right) in the unlikely setting of a recording studio. The occasion was the making of the record "There's a VIP Coming to Our Town," to commemorate the visit of Pope John Paul II in September 1987. It did not make the Billboard chart.

Four

JOS. CAMPAU

In 1905, Jos. Campau was a dusty dirt road that only hinted at its future development. It was only a few years earlier that electric lines had come to the village, and horse-drawn buggies were still common. Note the "office" of Justice of the Peace Louis Merique at left, next to the awning. Over the years, Jos. Campau would become the main artery of the city and in many ways the barometer of its fortunes.

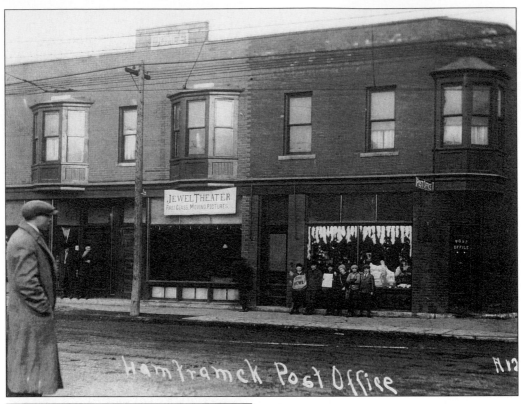

The Jewel Theater was perhaps Hamtramck's first movie house. This set of buildings was erected in 1912 and 1913 on Jos. Campau at Council Street. They are still standing and have recently been renovated. Also note the post office on the corner.

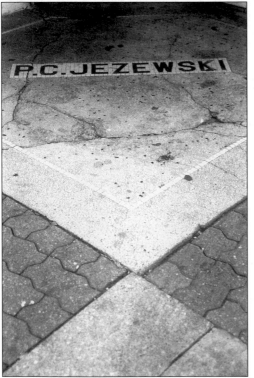

Although he is long gone, the name of Peter C. Jezewski lives on underfoot. The tiled entrance way to his pharmacy at Belmont and Jos. Campau still bears his name. Jezewski became Hamtramck's first mayor in 1922.

These buildings might be just south of Hamtramck on Chene Street. But they were typical of the style of the time with large glass windows and bay windows above.

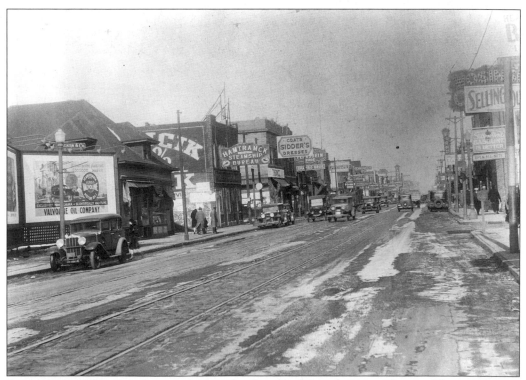

By the early 1920s, Jos. Campau had evolved into a major shopping district. This is the area south of Holbrook looking north. Note the Hamtramck Steamship Bureau on the left, which was important to the immigrants, and Farnum Theatre just visible on the right. The Baker Streetcar lines run down Jos. Campau.

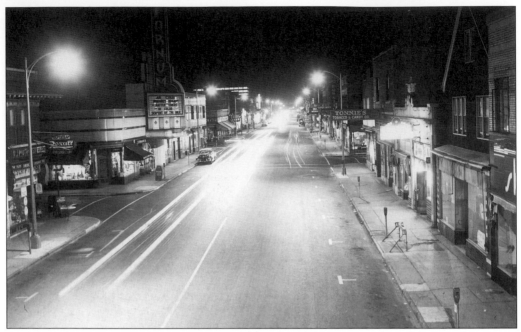

Farnum Theatre was on Jos. Campau and Wyandotte. Farnum lasted longer than most neighborhood theaters, surviving until the late 1960s. At one time there were eight movie houses in Hamtramck.

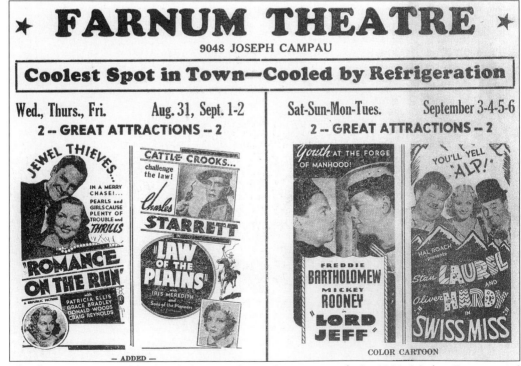

The fare at most neighborhood theaters changed twice a week. In 1938, Mickey Rooney and Laurel and Hardy were star attractions at the Farnum.

The Star, later White Star Theater, was just a few blocks north of the Farnum. The bill regularly included Polish films, as were being shown here in 1938.

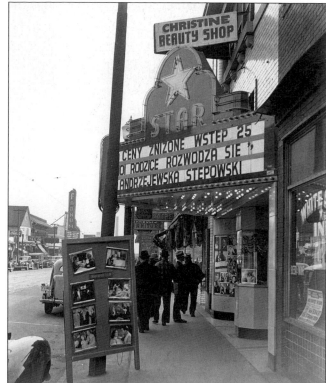

When this photo was taken in about 1940, the viaduct had been built and traffic flowed freely past the huge Dodge Main factory, which was characterized by its large smokestack. The viaduct, built in 1927, eliminated a bottleneck at the rail lines.

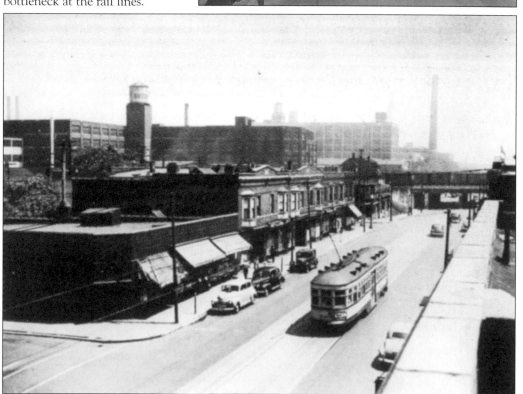

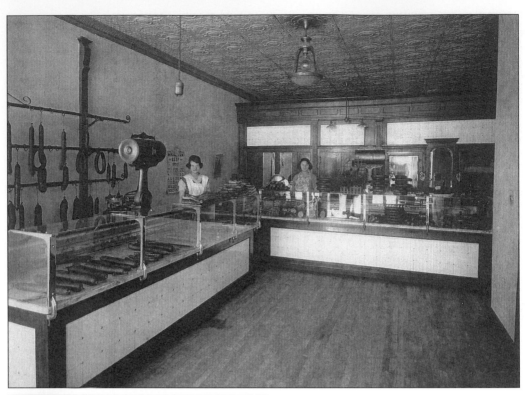

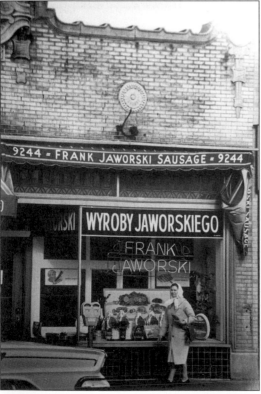

Links of kielbasa and other sausages hang on the wall of the Frank Jaworski's sausage store on Jos. Campau in 1928. The setting was sparse but spotless. The tin ceiling was common for the time and many examples of it remain.

A venerable company, the Jaworski Sausage Company store had evolved by the 1960s, but its products were still basically the same handcrafted ethnic delicacies.

Jos. Campau was burgeoning with stores in 1938 when this photo was taken. The street became known for its high-quality products and attracted shoppers from across southeast Michigan.

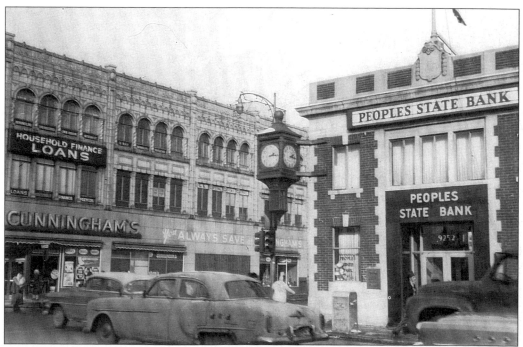

Two Hamtramck landmarks anchored Holbrook at Jos. Campau. Cunningham's Drug Store was one of a pair on Jos. Campau. Peoples State Bank, with a modernized exterior, remains in business today.

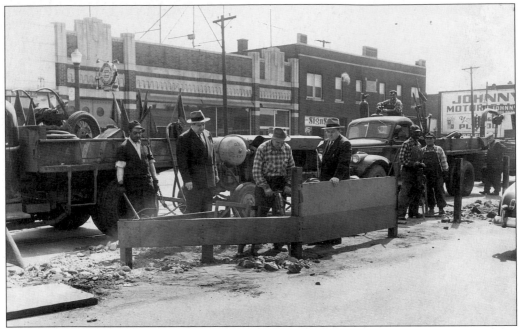

In 1952, city workers removed the "safety zones" on Jos. Campau north of Caniff. The zones were designed to help prevent the numerous traffic and pedestrian accidents that plagued the city, especially in the 1930s.

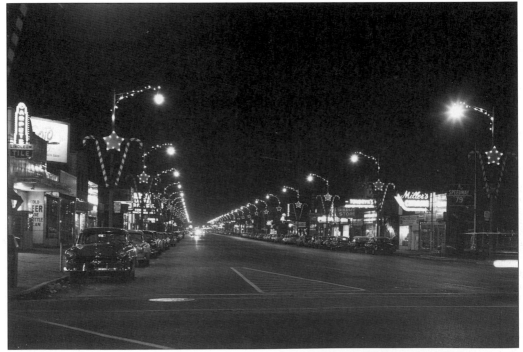

North of Caniff, in the 1950s when the shopping district was at its peak, the street glowed with Christmas cheer. All manner of stores could be found along the street, but this area especially was known for its many car dealerships.

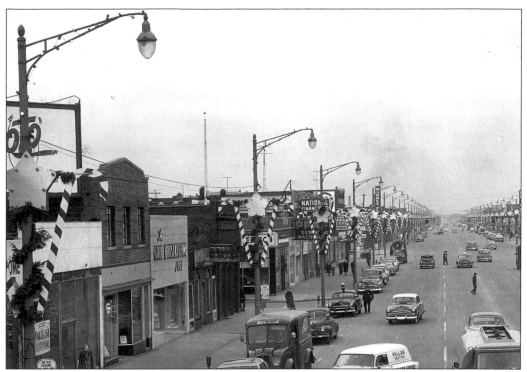

This photo of the same area loses some of its luster in the daylight, but still reflects the broad base of businesses.

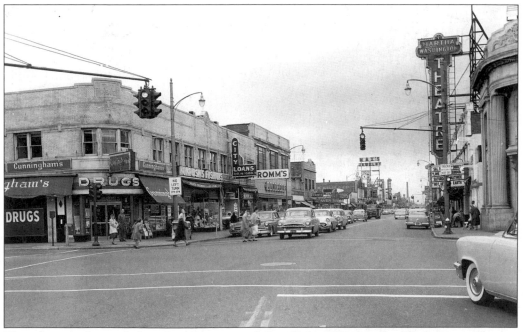

This photo looks south from Jos. Campau and Caniff. In 1957, Martha Washington Theatre was still a favorite neighborhood movie house. On the left is Cunningham's Drug Store. Another Cunningham's anchored the south end of the shopping strip at Holbrook.

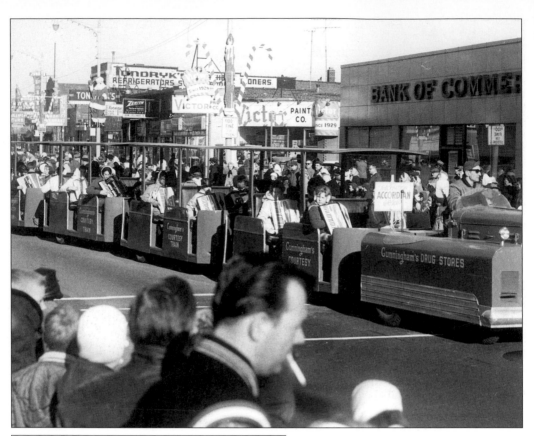

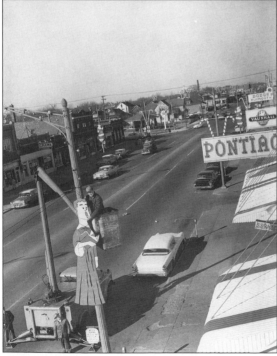

Cunningham's didn't just invite people into its stores; it went out to meet them. In this photo, the Cunningham's Courtesy Train carries people down Jos. Campau during a parade in the early 1960s.

City worker Ed Layman attaches a Christmas figure to a light post near the northern border at Carpenter in the late 1950s. In this short stretch, Pontiac, Dodge, and Chevrolet dealerships are packed together.

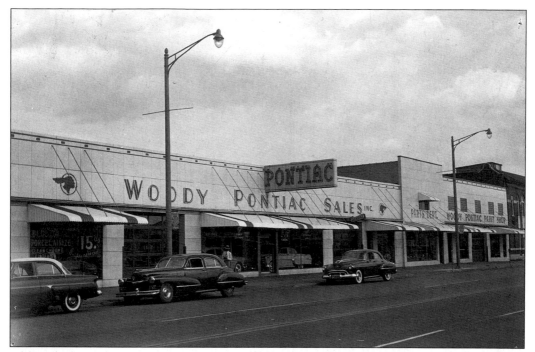

Although there were many dealerships on Jos. Campau, and some still remain, the granddaddy of them all was Woody Pontiac. Founded in 1940 by Woodrow W. Woody, his dealership became the number one Pontiac dealer in the country.

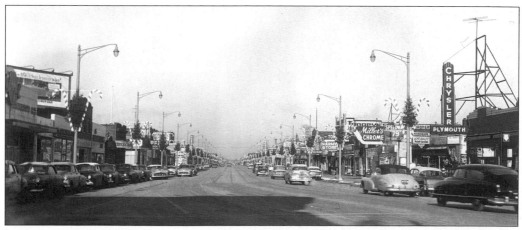

Looking north from Caniff is a sea of signs, including a Chrysler Plymouth dealership. Not as visible are several more dealerships, mechanics and suppliers that flourished there.

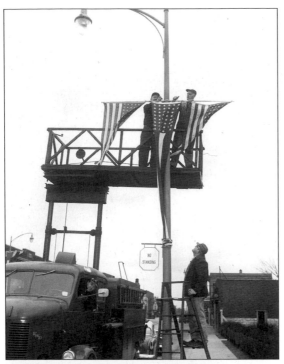

City workers attach flags to light poles around 1940, probably for a Memorial Day parade. Hamtramck loves parades, a tradition that continues today on Labor Day.

The safety patrol was in full uniform for the Christmas parade on Jos. Campau in November 1962. The annual parade, sponsored by the Hamtramck Recreation Department, kicked off the shopping season

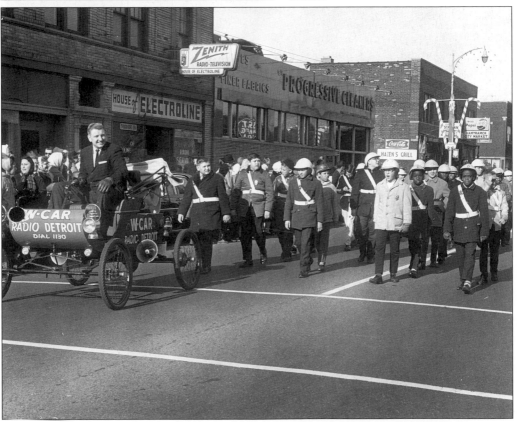

The old gas storage towers at the city's far south end are still remembered by some Hamtramckans. Jos. Campau is in the foreground, spanned by the distinctive pedestrian overpass leading to the Dodge Main plant.

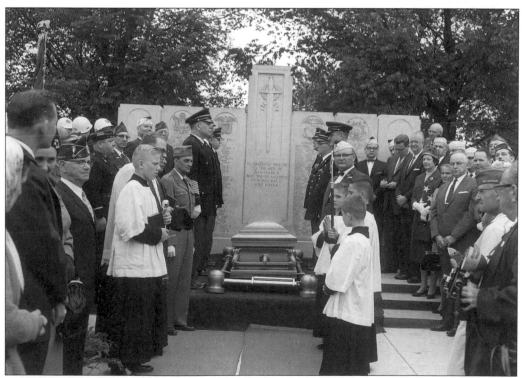

Just a few feet from Jos. Campau lies the grave of Col. John Francis Hamtramck, the city's namesake. A French-Canadian by birth, Col. Hamtramck distinguished himself fighting for the Americans in the Revolutionary War. His remains were moved from Detroit to Veterans Memorial Park in May 1962.

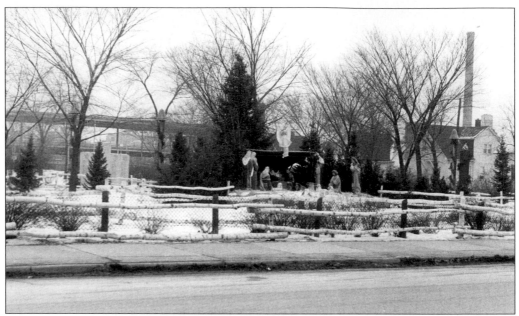

In less politically correct times, in 1955, the city erected a Nativity scene in Veterans Memorial Park to commemorate Christmas. The scene was not challenged as a violation of the separation of church and state; it was embraced by Hamtramck residents.

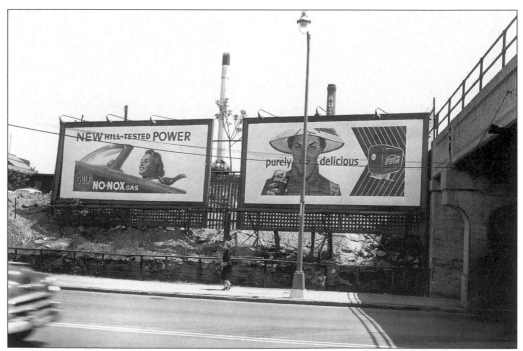

Gulf Gas and Coca-Cola made their statements on Jos. Campau and the viaduct in 1954. Through the 1950s, ground-level billboards were displayed on Jos. Campau.

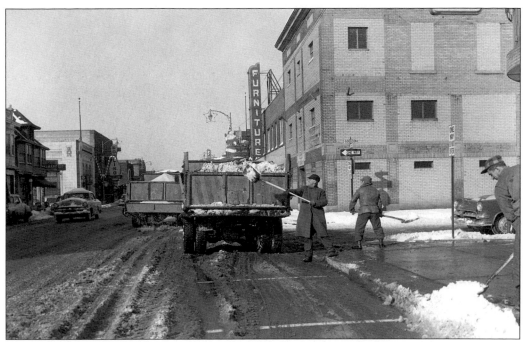

City workers shovel snow on Jos. Campau and Goodson in 1957 after a major snowstorm. This was one of the many city services provided at the time.

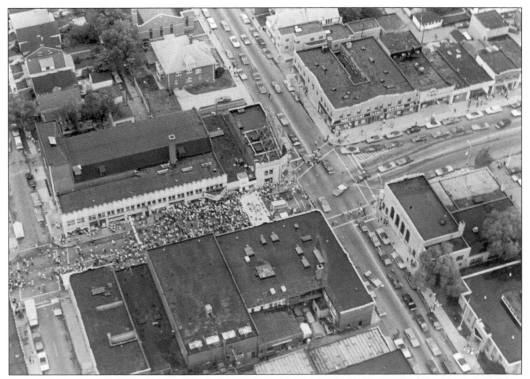

In 1972, thousands of residents flooded Jos. Campau to mark the city's 50th anniversary. This aerial view focuses on Jos. Campau and Caniff. West is at top.

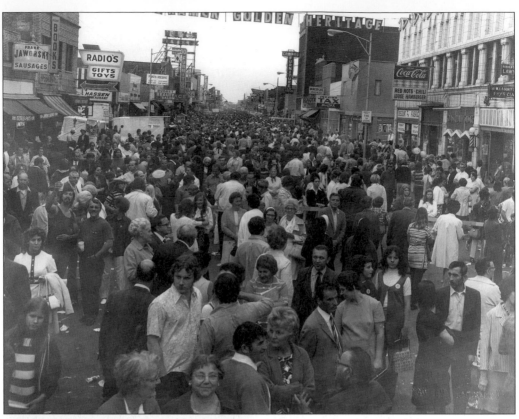

Jos. Campau was packed with people for the 50th anniversary celebration in 1972. This photo looks south.

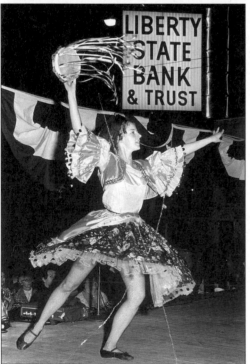

A Polish dancer twirls below the Liberty State Bank & Trust sign at Holbrook and Jos. Campau as the 50th anniversary celebration extends into the night.

Five

THE QUALITY OF LIFE

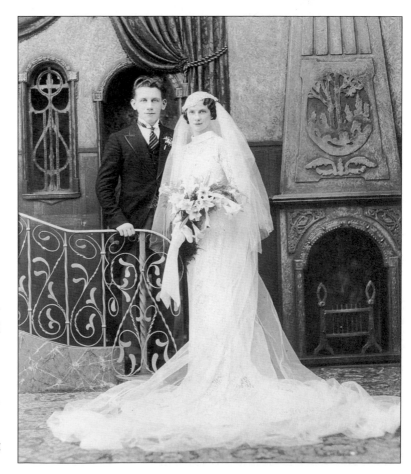

With the splendor of the 1920s, Lester and Agnes Hudziak pose for their wedding picture. The fashions and ornate backdrop were standard for the time, and everyone tried to have a studio-posed wedding photo taken.

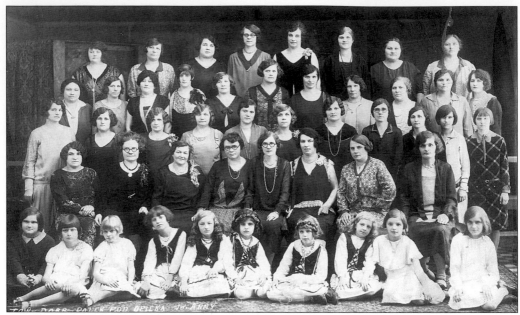

The Polish Women's Alliance posed for this photo in 1928. The PWA was one of numerous Polish and Polish-American organizations that flourished into the 1970s. Some, such as the Polish National Alliance, which was formed in 1880, remain active today. Such organizations have kept the cultural heritage strong.

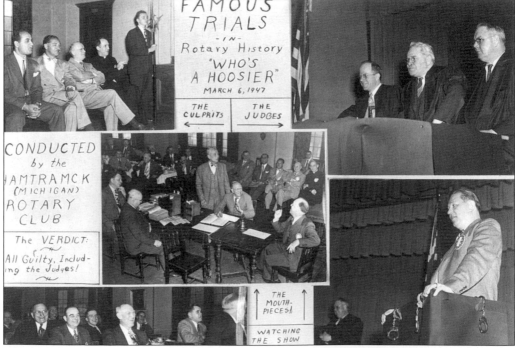

Along with the PNA, many social, ethnic, and veteran organizations thrived in Hamtramck over the years. One of the most venerable was—and is—the Rotary Club. In 1947 the Rotarians had some fun with a mock trial over a football game.

The PNA Council 122 Hall on Conant was built in 1950 and remains in use today. The PNA was instrumental in helping Polish immigrants adapt to American society over the decades.

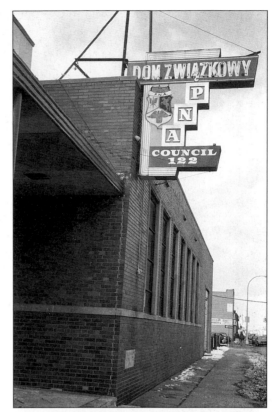

The Malaga Caravan No. 8 International Order of the Alhambra was another significant service organization. In 1971, the Alhambra donated a Dodge maxi bus to the public school district to transport special education children.

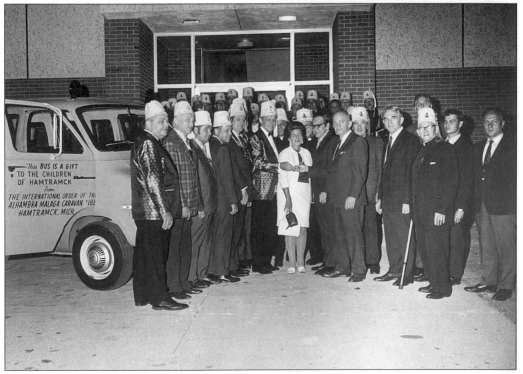

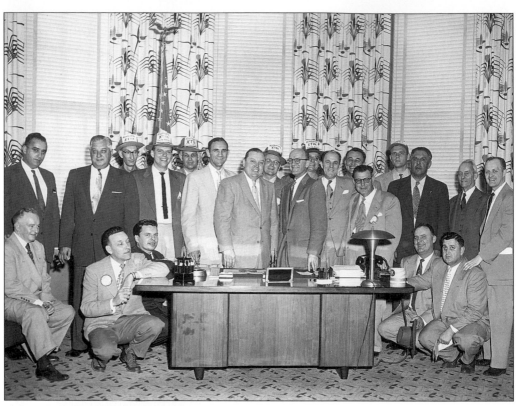

Because most residents came from poor and immigrant families, Hamtramckans have traditionally been generous people. Many service organizations thrived in the city, and participated in charitable activities. In 1954, the members of the Kiwanis Club posed for a fund-raiser in Mayor Albert Zak's office.

Slab sidewalks and rickety barns were standard at most houses. About 80 percent of the homes in Hamtramck were built between 1915 and 1930. They were generally wood frame homes and had outhouses or toilets in the barn. By 1945 all of the toilets had been moved indoors. This photo of a yard on Wyandotte Street dates from about 1945.

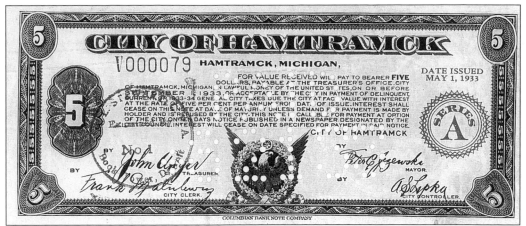

As the Great Depression hit hard, cash-strapped Hamtramck began issuing its own scrip, which was used to pay city employees. It later was redeemed for regular Federal currency.

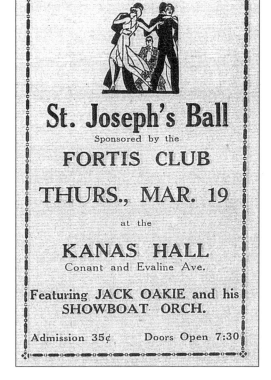

St. Joseph's Ball

Sponsored by the

FORTIS CLUB

THURS., MAR. 19

at the

KANAS HALL

Conant and Evaline Ave.

Featuring JACK OAKIE and his SHOWBOAT ORCH.

Admission 35¢ Doors Open 7:30

Dances were common for decades and weren't confined to Saturday nights. The St. Joseph's Ball sponsored by the Fortis Club was held on a Thursday at the venerable Kanas Hall. The hall was destroyed by the tornado of 1997.

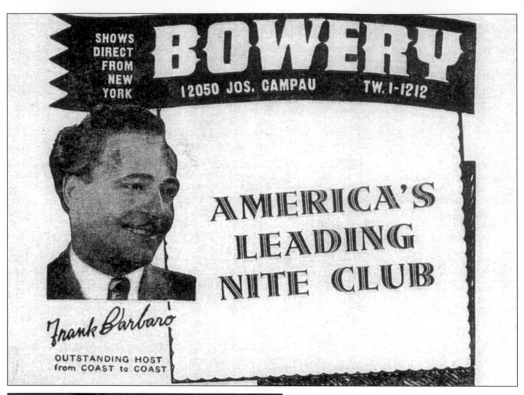

SHOWS DIRECT FROM NEW YORK

BOWERY

12050 JOS. CAMPAU TW. I-1212

AMERICA'S LEADING NITE CLUB

Frank Barbaro

OUTSTANDING HOST
from COAST to COAST

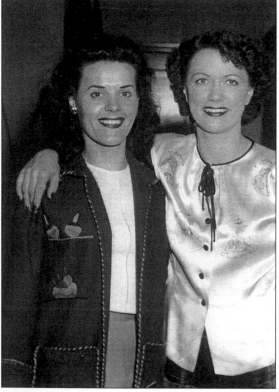

Community dances were a lot of fun, but for real entertainment, it was hard to beat the Bowery on Jos. Campau. Frank Barbaro's nightclub was one of the best in the Midwest and attracted such headliners as Sophie Tucker, Jimmy Durante, the Three Stooges, Danny Thomas, and many others. After Mr. and Mrs. Barbaro were divorced in the early 1950s, the Bowery closed.

Actress Eleanor Powell was among the many Hollywood stars to visit the Bowery in its heyday in the 1940s. Powell starred in such films as "Broadway Melody of 1936" and "I Dood It," with Red Skelton.

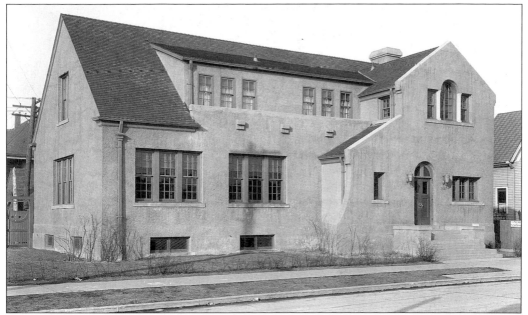

This is the Tau Beta Community House as it looked in 1923. Tau Beta was one of the most beloved organizations in the city's history. Beginning in 1915, Tau Beta provided a variety of services from visiting nurses to theater productions. Thousands of Hamtramckans belonged to Tau Beta until it ceased operations in 1958.

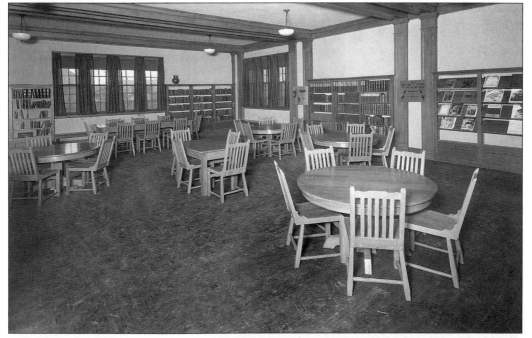

One of the major accomplishments of Tau Beta was the organization of the town's first library, in 1918. The library would move several times—to a storefront on Jos. Campau, and the second story of the T.T. Dysarz (now Garfield building) at Jos. Campau and Caniff—before the current library building on Caniff was built in 1956.

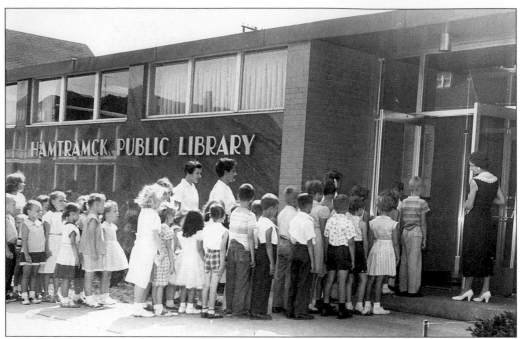

As soon as it opened in 1956, the Hamtramck Public Library became a focal point of the community, and remains so today. Then, as now, students flocked to the library on a daily basis.

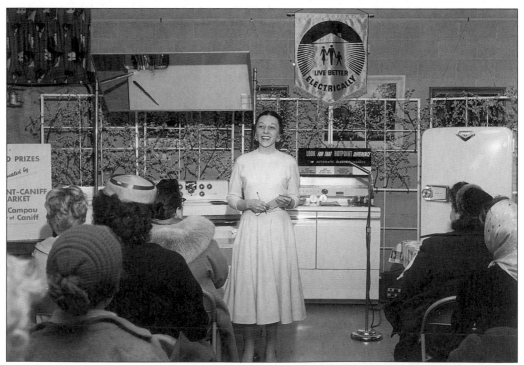

More than repository of books, the Hamtramck Public Library has traditionally sponsored community outreach programs. During National Library Week in March 1958, Detroit Edison held a cooking demonstration at the library.

The ornate birdhouse in Zussman Park in front of city hall was a community landmark for many years. Such amenities added a touch of character to the city. The birdhouse lasted into the 1970s when it finally fell apart.

St. Francis Hospital opened in 1927 to serve the needs of the predominantly Polish community. It had a largely Polish-speaking staff in its early days. Two mayors, Dr. Rudolph Tenerowicz and Dr. Stephen Skrzycki, were on staff there. The hospital closed in 1968, and the following year the hospital was converted into a "temporary" city hall. It still is functioning as city hall.

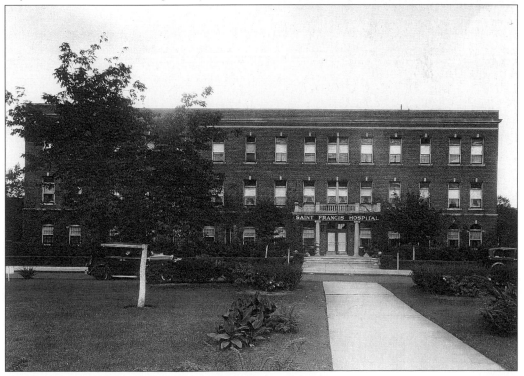

Sports and recreation have traditionally played an important role in the fabric of Hamtramck. In 1940 the grandstands were built at Veterans Memorial Park.

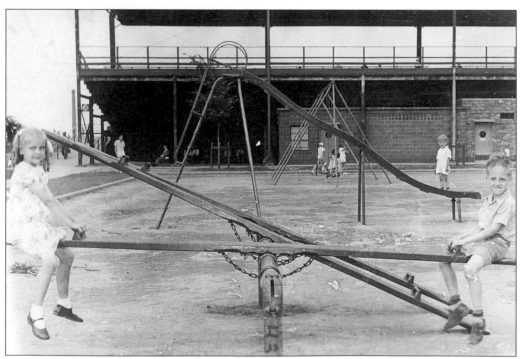

Thousands of Hamtramckans can remember playing at Veterans Memorial Park. Recently, the Preserve Our Parks community organization restored the playscape, which had fallen into disrepair since this photo was taken in the 1950s.

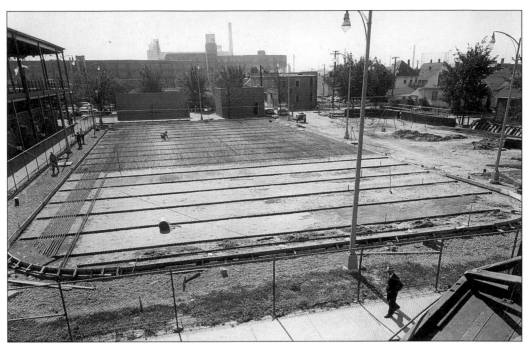

A grid of cooling pipes is being installed as the new ice rink at the park is being built in November 1955.

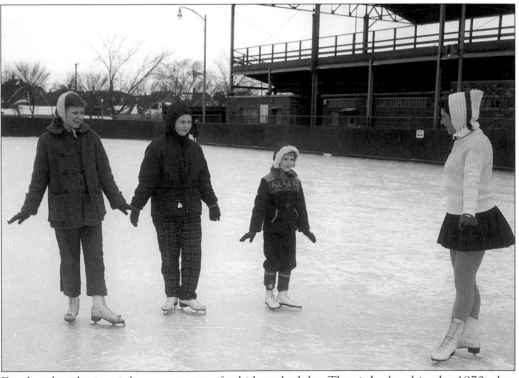

For decades, the ice rink was a magnet for kids and adults. The rink closed in the 1970s, but was recently reborn as an in-line skating rink.

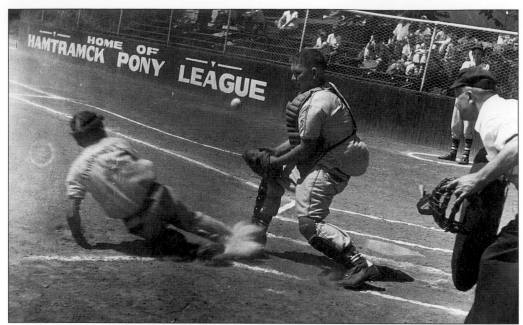

Veterans Memorial Park also provides baseball diamonds for Little League and Pony League teams. This early 1960s scene notes prominently that the diamond is the home of the Hamtramck Pony League, which won the national Pony League championship in 1961.

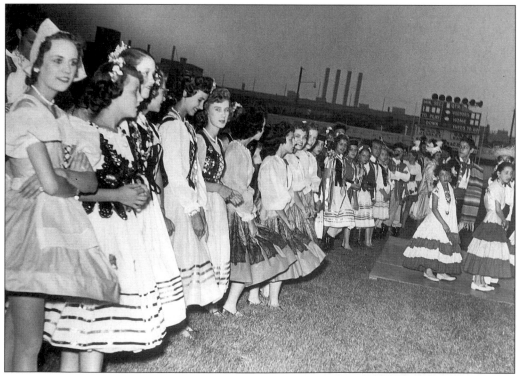

In July 1958, Keyworth Stadium hosted another type of team—a troupe of Polish dancers. To this day, Polish dancers in ethnic costumes are a mainstay at community events.

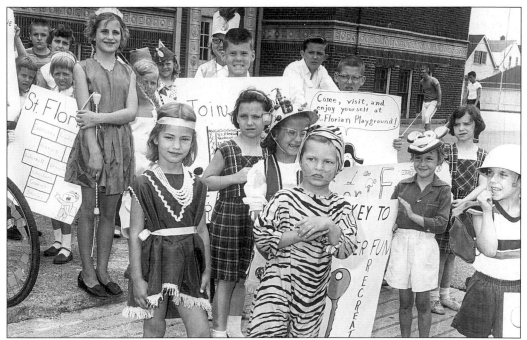

In what were called "novelty parades," the kids turned up in costumes to promote the opening of summer recreation programs each year. These youngsters took to the streets in July 1962.

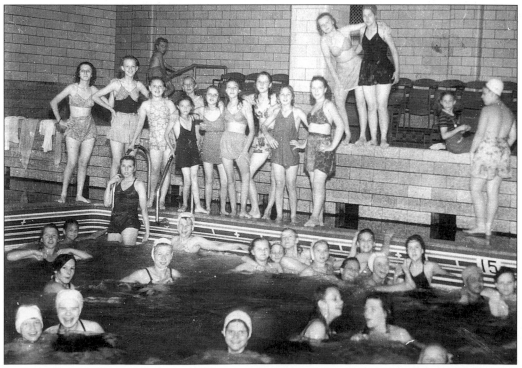

Swimming was a key component of the recreation department program and always drew a full pool of youngsters at Copernicus School.

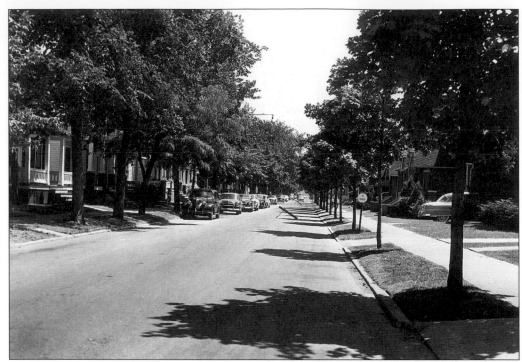

Gallagher was a typically neat tree-lined street in the early 1950s. Many of these trees, however, were doomed. Dutch elm disease already was appearing and would devastate whole streets, changing the character of the neighborhoods.

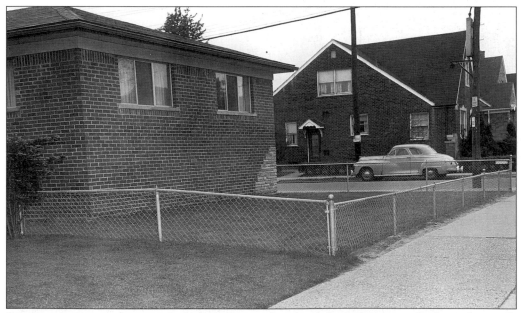

In an attempt to compete with the suburbs, modern brick bungalows were built on the north side of town after World War II. But many residents couldn't resist the lure of the wider lots of the suburbs.

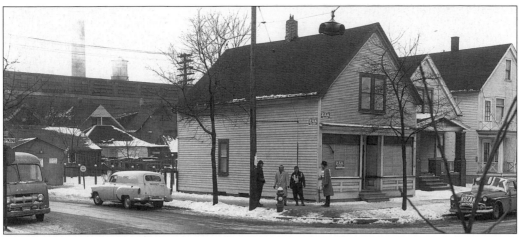

Old homes and corner stores, standing in the shadow of the Chevrolet Gear and Axle, typify Hamtramck to this day. This is at the corner of Lumpkin and Andrus in the 1950s.

Equally typical of Hamtramck homes were immaculately-kept small back yards. It's a tradition that continues today.

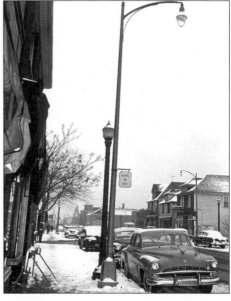

This is a typical Hamtramck street scene in about 1950. The location is at Caniff near Lumpkin. Although the scene seems rather ordinary, the city was beginning to fray a bit. The houses, such as those at right, were aging and many needed repairs. Ironically, the decorative street lamps are becoming popular once again in communities.

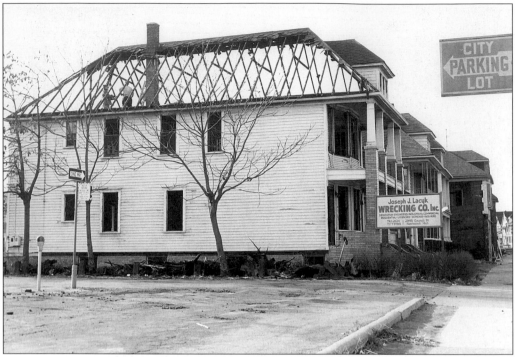

To deal with the aging housing stock and creeping blight, Hamtramck officials embarked on an urban renewal program in the 1950s—with devastating consequences. By the late 1960s the city would be charged with using urban renewal to force out African-American residents. That led to a lawsuit that lasted more than 30 years.

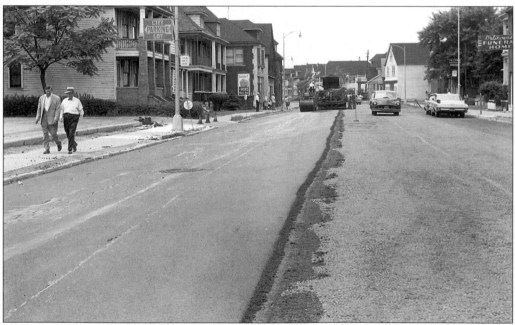

Holbrook west of Jos. Campau gets a new coating of asphalt as the city embarks on a road improvement program in the 1950s.

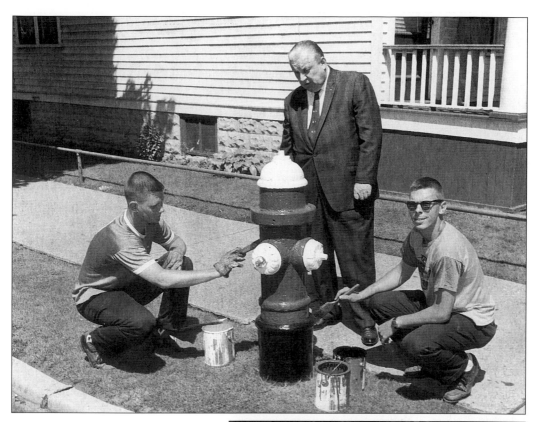

In an effort to spruce up
Hamtramck's image, Mayor Albert
Zak placed great emphasis on the
city's appearance. City sweepers
were out almost daily and even the
fire hydrants were painted regularly.
This dates from about 1957.

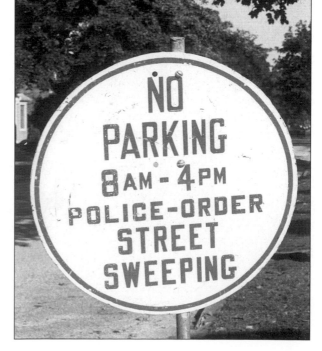

The round "No Parking" for street
sweeping signs were a common sight
during Mayor Albert Zak's
administration, between 1952 and
1963.

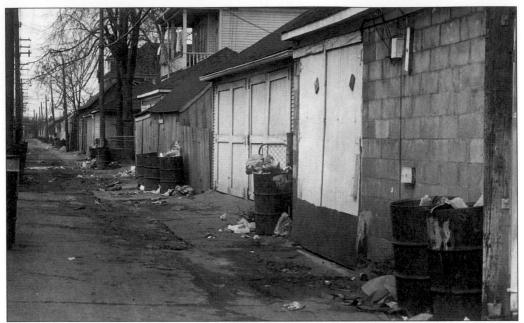

Even while Mayor Albert Zak was having the streets swept, trash remained an overflowing problem in the alleys. The trash problem is evidenced in this 1957 photo of an alley between Holbrook and Lehman running from Gallagher to just east of Jos. Campau. Soon the city would pass new laws forbidding the 55-gallon oil drum cans. But trash remains a problem today.

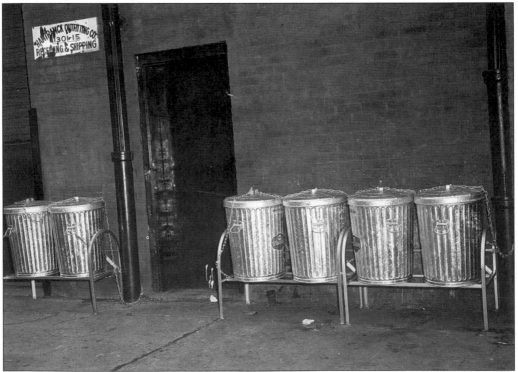

After oil drum trash cans were outlawed in 1957, residents switched to modern cans on raised racks.

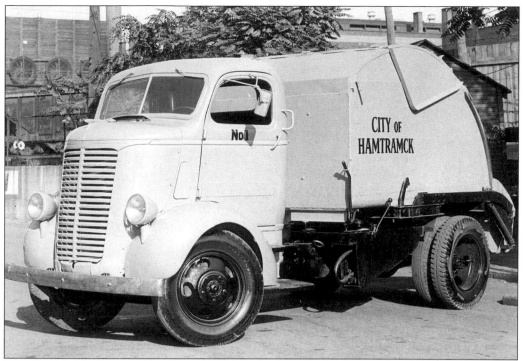

In the war against grime, the city bolstered its arsenal with a slick garbage truck in the late 1950s.

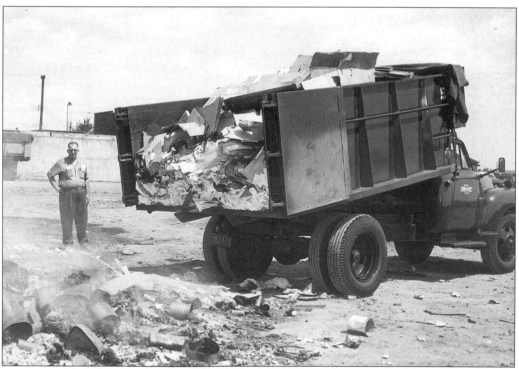

A load of trash is dumped at the city yards on Alpena Street. This would soon be a scene of the past as the city began construction of a new incinerator in 1957.

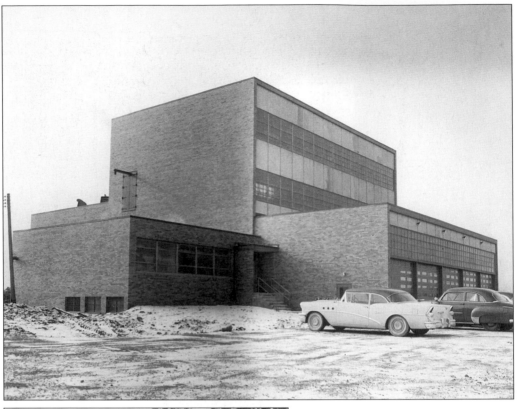

Completed at a cost of $673,000 in 1957, the incinerator allowed the city to discontinue hauling trash to a dump at 13 Mile and Dequindre. But the facility was never operated properly and eventually was deactivated and demolished.

City Hall	Central Police and Fire Stations

Hamtramck's Immediate Challenge . . . A New Civic Center

Re-Elect—
Your MAYOR Joseph J.
GRZECKI
Mayor Grzecki Keep Hamtramck Moving Forward

Dear Citizen:

Permit me to express my sincere appreciation for the opportunity extended me to serve as Mayor of Hamtramck, one of Michigan's finest communities.

Through your cooperation we were able to embark on a forward-looking program. Several phases of this program have already been achieved. Construction of a new civic center presents us with a challenge. The planning stage is complete and actual construction is not too far distant.

Your continued support of this administration and its program for the betterment of Hamtramck is important to the future of our community.

Sincerely yours,

Joseph J. Grzecki

Mayor

Don't Forget To Vote Monday, February 19, 1968

Residential Redevelopment . . .

Senior Citizens Housing . . .

Community Beautification . . .

By the late 1960s, Hamtramck was dealing with some serious urban blight and was in competition with the suburbs to retain residents. Mayor Joseph Grzecki appealed to voters in 1968, identifying a wish list of facilities that would strengthen the city. This bid did produce results for Grzecki as he was re-elected. But when none of these projects materialized, he was defeated by Raymond Wojtowicz two years later.

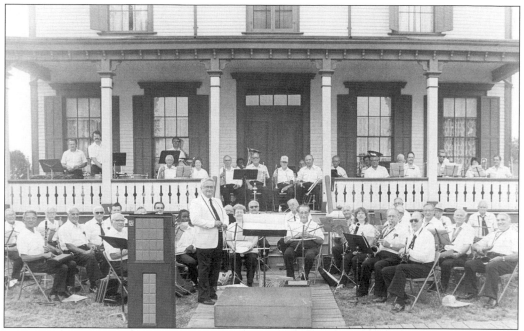

Even as Hamtramck dealt with declining population and aging infrastructure in the 1970s and 1980s, the city kept its cultural ties. Here the Hamtramck Concert Band, under the direction of Steve Woloson, practices for the visit of Pope John Paul II in 1987.

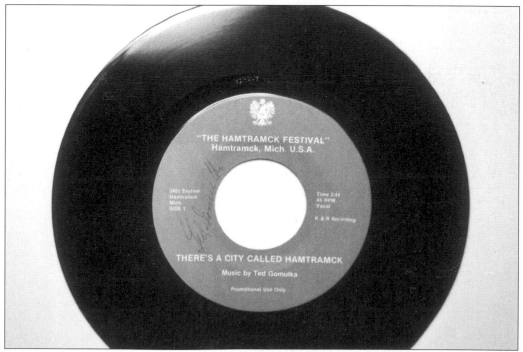

In keeping with the city's musical tradition, Ted Gomulka recorded "There's a City Called Hamtramck" for the annual city festival. There actually are numerous recordings referencing Hamtramck, including the ever-popular "Hamtramck Mama."

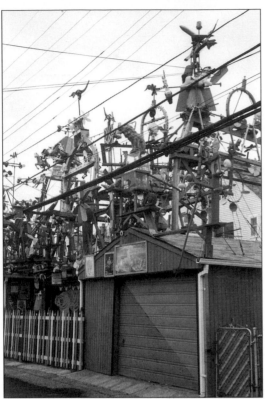

Through all of its years, Hamtramck has maintained a whimsical nature, as well. "Hamtramck Disneyland," built in a back yard between Pulaski and Klinger streets, draws numerous visitors. The colorful, whirling figures are the work of artist Dmytro Szylak.

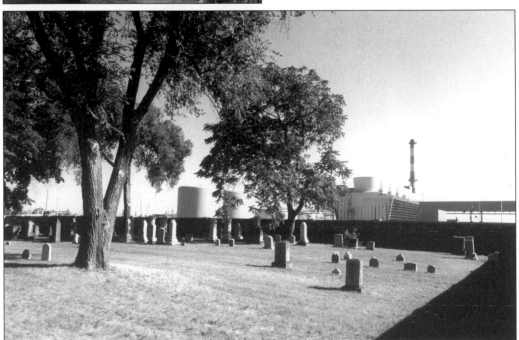

Death also figures into the final act of the quality of life. Nearly forgotten, Beth-olem cemetery, established in 1871, is now completely encompassed by the GM Poletown plant. The last burial was more than 50 years ago.

Six

TO PROTECT AND SERVE

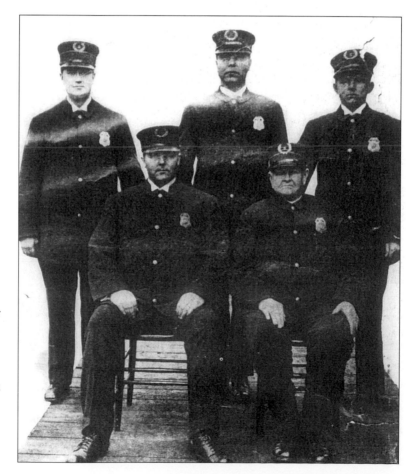

Members of the village police department posed for this photo. The date is not known but probably is about 1915. Pictured from left to right are Mark Berlinger, Chief Barnard Whalen, Earl Thompson, Daniel O'Brien, and John Ferguson.

A daily report from the Village Fire Department, from 1920 or 1921. Note the elegant handwriting.

The fire department log book for July 18, 1918, lists every call made. Responses to actual fires were written in red ink.

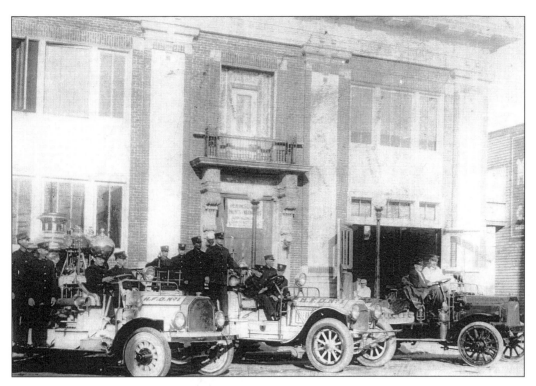

The gleaming new steam fire trucks were state-of-the-art when they arrived in Hamtramck in about 1914. Note the solid tires and chain drive shafts. The firefighters are posing at the municipal building at Jos. Campau and Grayling.

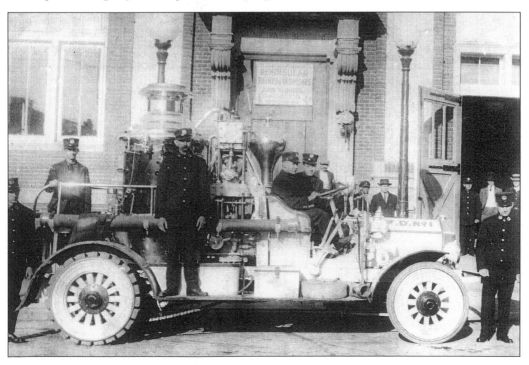

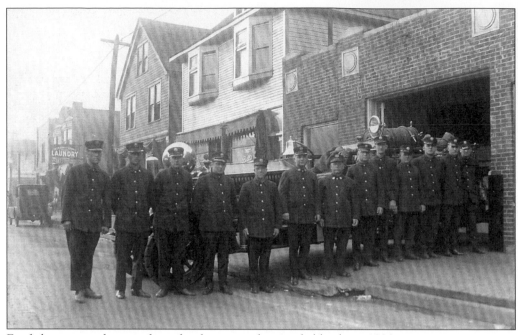

Firefighters turned out in force for this group shot, probably about 1920.

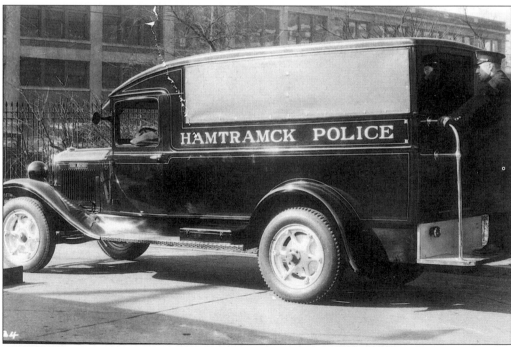

The 1929 Dodge Paddy wagon rolled along on 63 horsepower. The design originated with troop carriers produced by Dodge in World War I.

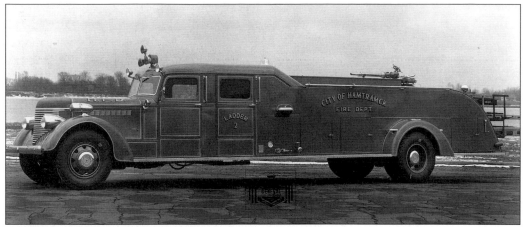

By 1938, fire trucks were fairly sophisticated. Built by the General Fire Truck Corp. of Detroit, this model had an enclosed five-man cab. It was sold for scrap in 1956 when the truck in the next photo was bought.

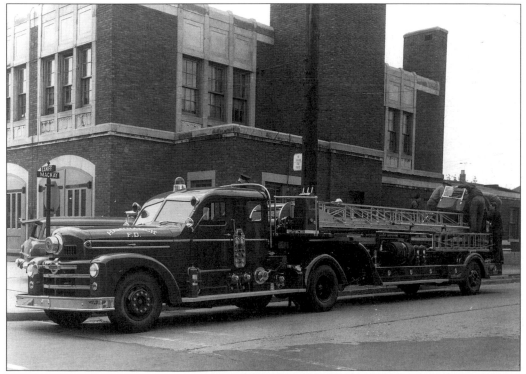

Posed next to the fire station at Caniff and Mackay, this 85-foot ladder truck was bought in 1956. It was capable of pumping 1,000 gallons per minute.

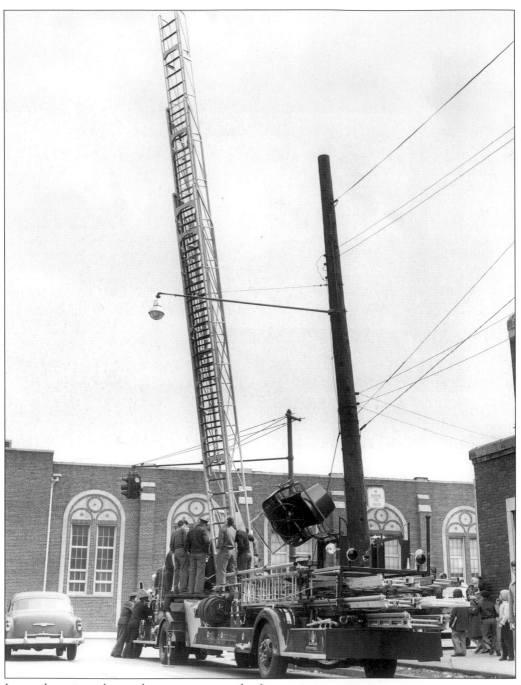

In another view, the truck gets a tryout at the fire station.

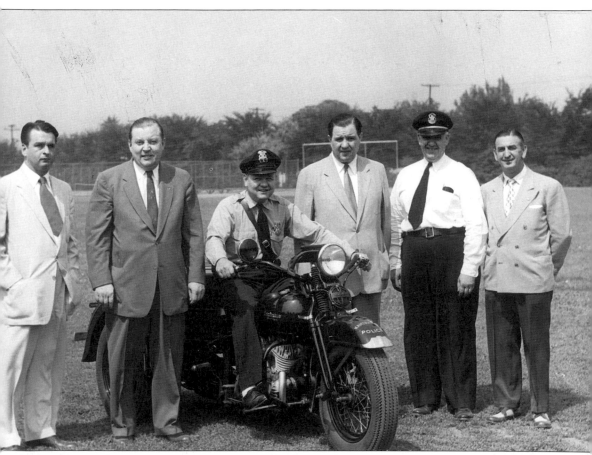

The police got their share of equipment as well. They took possession of a new motor tricycle in 1953. The name of the officer on the bike was not recorded, but the others are, from left to right, City Councilman Martin Dulapa, Mayor Albert Zak, City Councilman Henry Kozak, police Capt. Bieszka and City Treasurer Walter Bielski.

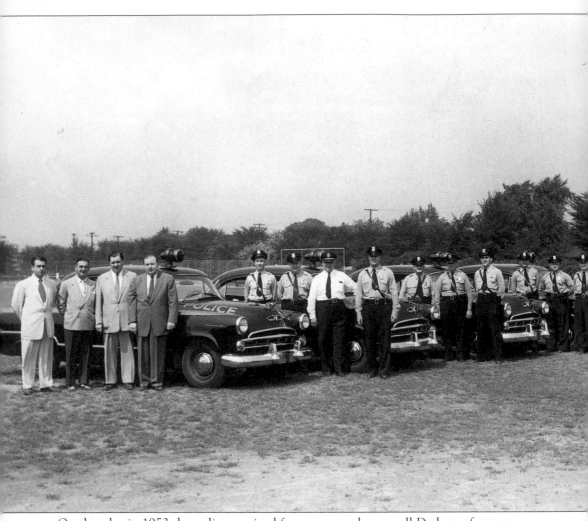

On that day in 1953 the police received four new squad cars—all Dodges, of course.

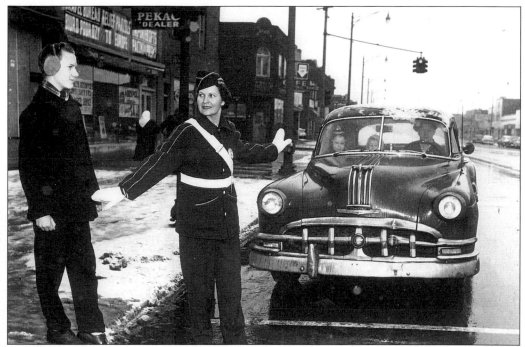

A safety crossing guard helps a pedestrian on Jos. Campau near Casmere. For years Hamtramck was plagued by traffic accidents caused by the heavy foot traffic and growing number of cars.

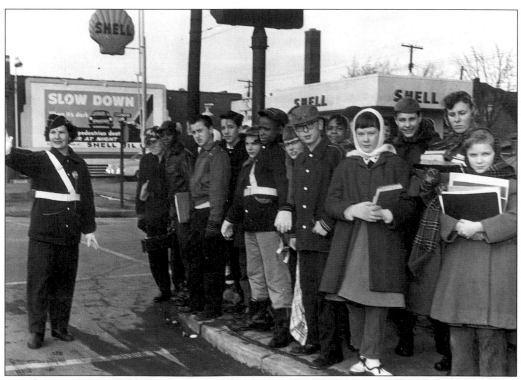

Another crossing guard helps students make their way across at Jos. Campau and Roosevelt.

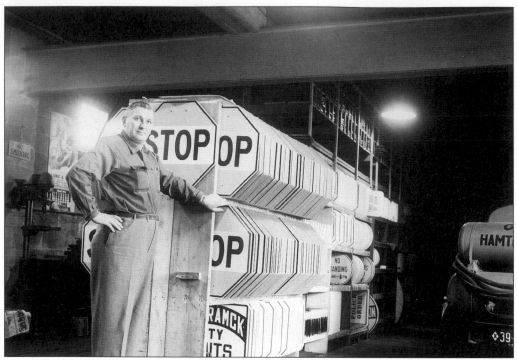

A freshly painted collection of street signs waits to be installed in the 1950s.

HAMTRAMCK POLICE
BENEFIT FIELD DAY

Proceeds to Juvenile and Retirement Funds

1st PRIZE — 1958 DODGE

JULY 27, 1958 - 10:00 a.m.
at WARSAW PARK
DEQUINDRE and 21 MILE ROADS
• **DONATION 50c** •

The Decision of The Judges will be Final.
This is a Ticket of Admission to the Park.

FREE DRAWING

50

OTHER PRIZES

N⁰ 26034

Always loyal to Dodge, the Hamtramck Police Benefit Field Day in July 1958 featured a 1958 Dodge as first prize.

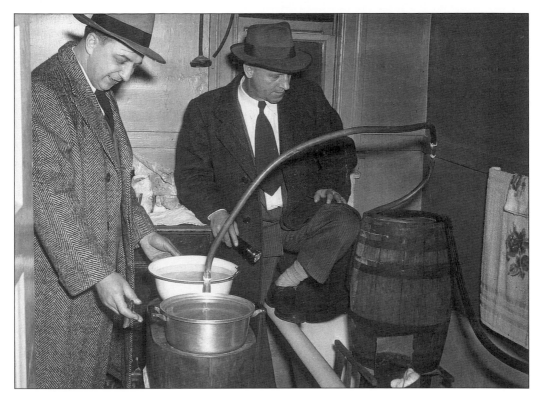

Police detectives look over a liquor still where the saying "bath tub gin" literally was true. Such illegal operations persisted in the city well beyond Prohibition. This one dates from about 1947.

Quacky Walker was a familiar figure to school children in the 1950s and 1960s. The pamphlet, put out by the Fraternal Order of Police, featured pictures for kids to color, as well as safety tips.

During the early years of the Cold War, Hamtramck had an active Civil Defense Department. This publication was distributed to residents to inform them of what to do in case of an atomic attack—and reassure them that nuclear war wasn't all that bad.

Seven

THE BUSINESS OF
HAMTRAMCK

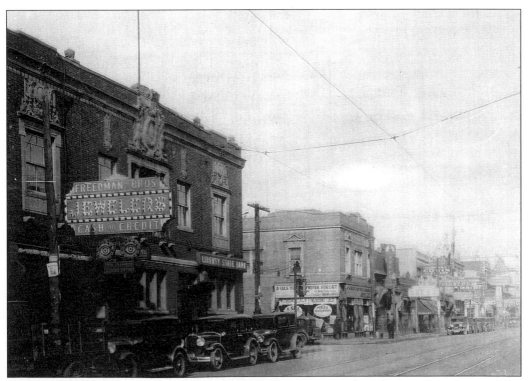

Liberty State Bank was founded in 1917 by Joseph Chronowski, who was forced out of the brewing business with the implementation of Prohibition. The bank was one of the few to survive the Great Depression and moved up just a block to the corner of Jos. Campau and Holbrook. The building now houses the Polish Art Center.

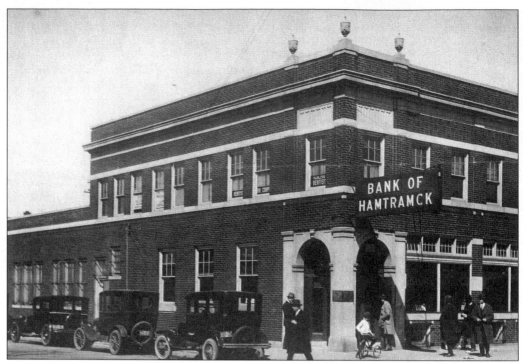

Bank of Hamtramck was founded in 1924 at the corner of Jos. Campau and Caniff. It started with simple services, only offering savings accounts, checking accounts, and mortgage and commercial loans.

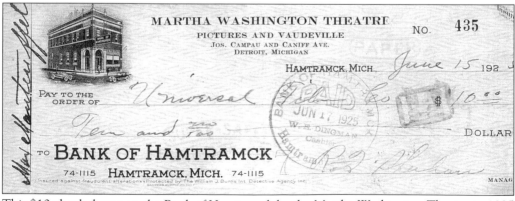

This $10 check drawn on the Bank of Hamtramck by the Martha Washington Theatre in 1925 is made out to the Universal Film Company.

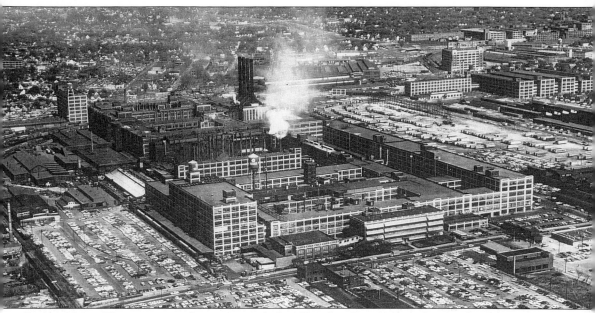

Dodge Main: Those two words summarized the Chrysler Corporation factory for 70 years. Founded in 1910, Dodge Main was the most important business in Hamtramck. It provided thousands of jobs and millions of dollars in tax revenue to the city.

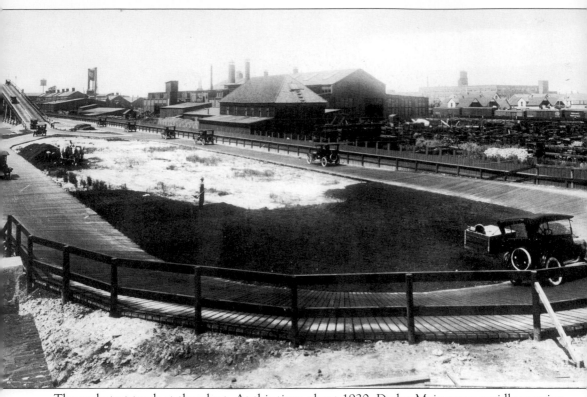

The early test track at the plant. At this time, about 1920, Dodge Main was a rapidly growing operation. It would expand to encompass more than 100 acres at the city's southeast section.

Hundreds of thousands of people worked at Dodge Main over the years. This is one of the worker's pins. The symbol, which looks like a Star of David, actually is an early Dodge emblem denoting precision design.

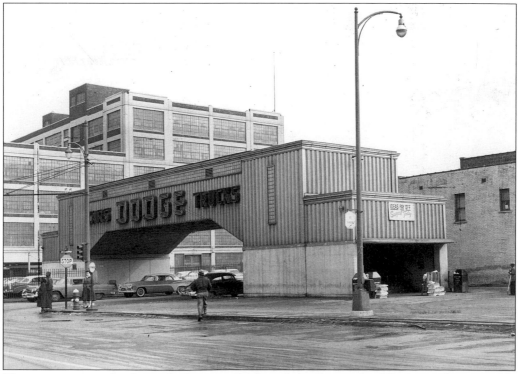

The overpass was a familiar sight for years. It allowed the thousands of Dodge workers to safely cross Jos. Campau.

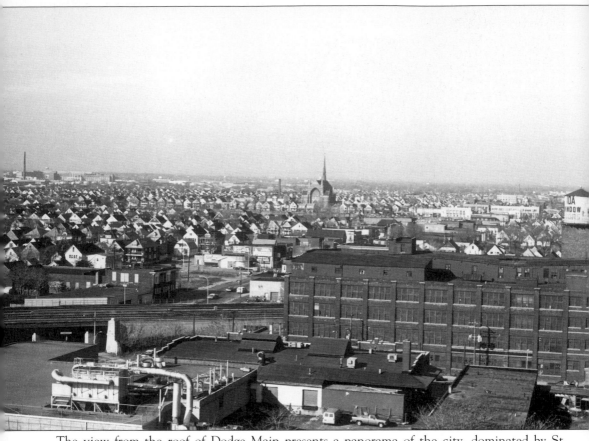

The view from the roof of Dodge Main presents a panorama of the city, dominated by St. Florian Church. But this is a somber photo. It was taken just days before demolition of the plant began in 1981.

Facing bankruptcy in the late 1970s, Chrysler could no longer afford to operate the aging plant. It was closed, but within months General Motors announced plans to build a new car plant on the site. That led to the demolition of Dodge Main, which was one of the largest demolition projects in the world.

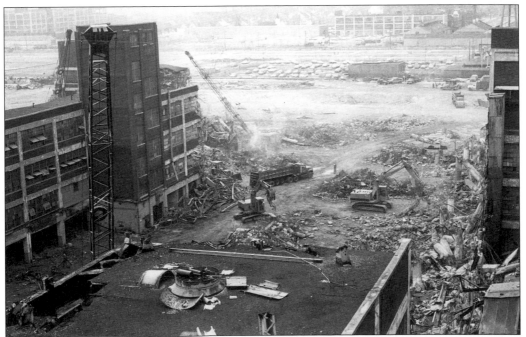

Demolition began at the south end of the plant and moved north. The walls were battered by 10,000-pound steel balls swung on cranes.

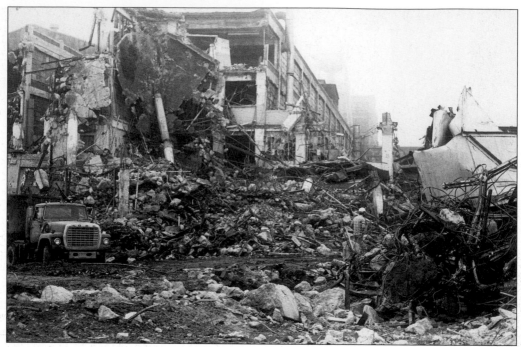

The size of the project and amount of debris was staggering. The plant had covered 5 million square feet of floor space and rose eight stories.

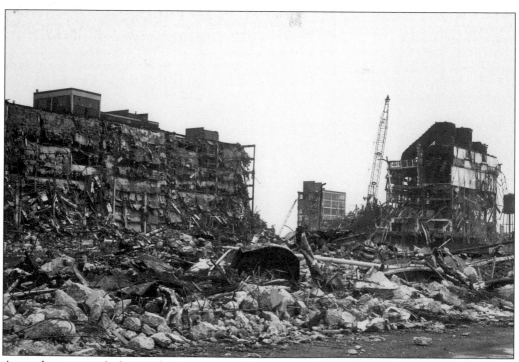

As work progressed, the site began to resemble a war zone. Total demolition took nearly nine months.

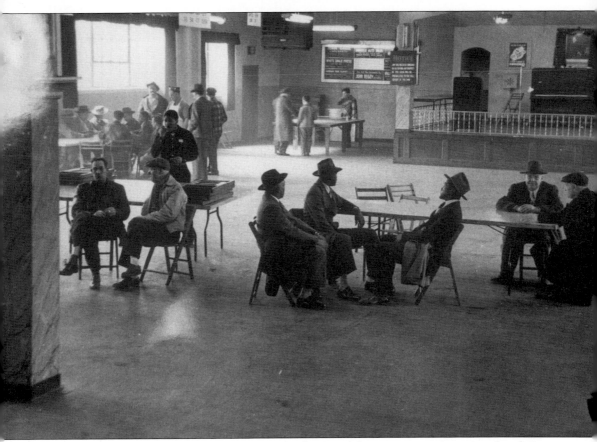

Born of the national labor unrest of the 1930s, Dodge Local 3 was a pioneering union local. In 1937, workers staged a massive sit down strike at Dodge Main, which helped lead to the auto industry's recognition of the United Auto Workers. The old Local 3 hall at Jos. Campau and Denton was torn down shortly after Dodge Main was demolished.

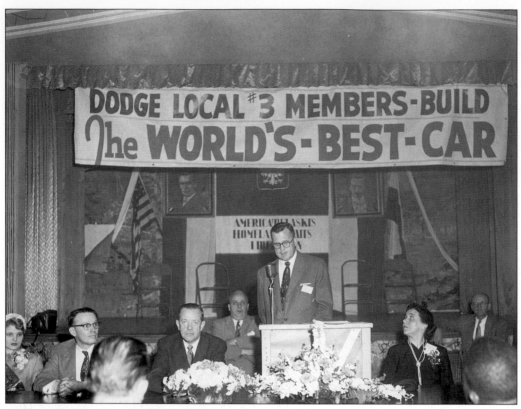

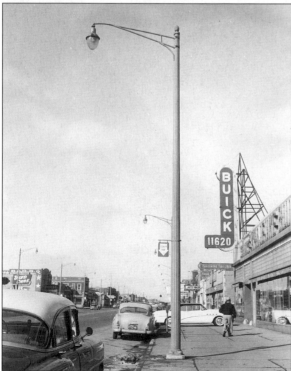

Dodge President William Newberg teamed with Dodge Local 3 to promote the Dodge Days celebration in 1954 to introduce the 1955 models. The party was at the PNA hall on Conant.

Dodges weren't the only cars in town. Pontiacs, Buicks, and Chevrolets were among the many cars for sale in Auto Row, which was the section of Jos. Campau north of Caniff. Several dealerships remain there today.

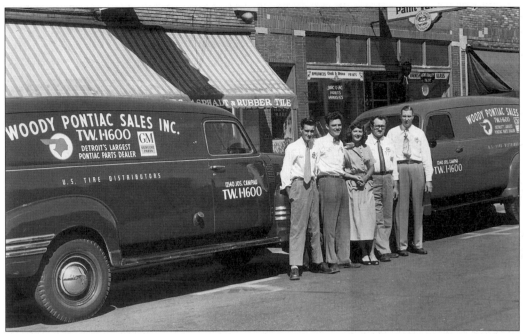

The crew from Woody Pontiac stands with some service vans. Woody was the leading dealer in the city for years. His familiar "hello, folks" TV commercials were known to generations.

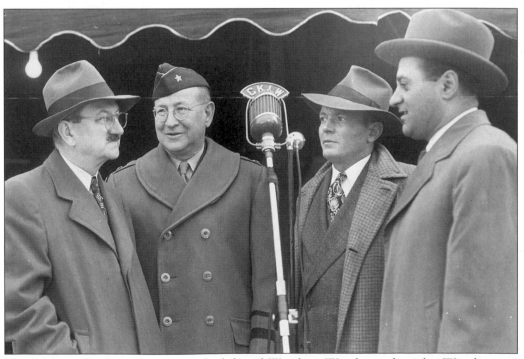

That's Mayor Stephen Skrzycki on the left and Woodrow Woody on the right. Woody was a patriotic American and lobbied for his native homeland of Lebanon. He was involved in numerable charitable activities and worked to get the Hamtramck Public Library built. He worked nearly every day until he retired past age 90. He died at age 94 in 2002.

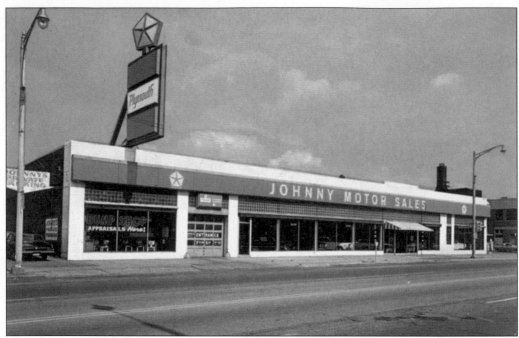

Johnny Motor Sales was another of Hamtramck's car dealerships.

The auto industry provided jobs in several ways. Cass & Sons at Jos. Campau and Roosevelt has been servicing cars for decades.

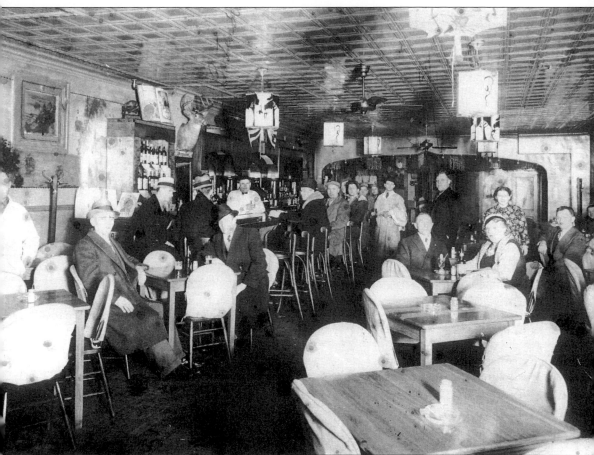

For a good dinner, Sam's Café was a great place to eat in the 1930s. Over the years, Sam's would evolve into Lili's Bar, which became nationally known as a hard rock venue and helped Hamtramck become named as one of America's "10 hippest towns in North America" by the *Utne Reader*, a leading alternative culture magazine.

Auto City Brewing Company was founded in 1910 and was the largest of four Detroit-area breweries operated by Polish immigrants. It was located at Hamtramck's South End near Denton. That's Dodge Main looming in the background.

Auto City knew its audience. This program guide from a 1936 WJBK radio show contains the lyrics featured on the show in Polish. The program was sponsored by Auto City.

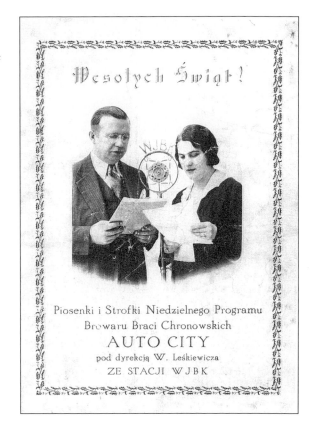

Wesolych Świąt!

Piosenki i Strofki Niedzielnego Programu
Browaru Braci Chronowskich
AUTO CITY
pod dyrekcją W. Leśkiewicza
ZE STACJI WJBK

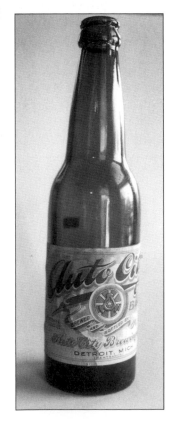

This is a surviving sample of an Auto City bottle. Strikes and layoffs in the 1930s affected sales, and Auto City went out of business in 1941.

C & K brewery, named after founder Casimir Kocat, was a typical small brewery. Founded in 1923, it went out of business in 1935. But the building at Sobieski and Casmere remains.

Opposite: Konrad Koppitz and Arthur Melchers established their brewery in 1890 in Detroit, and found a waiting pool of customers in Hamtramck. The city was a logical site for one of their distribution outlets, which was located at Mackay and Pulaski. The brewery survived Prohibition but went out of business in 1947.

Pulaski Distributors

11813 Mackay cor. Pulaski

Hamtramck, Mich.

KOPPITZ MELCHERS Inc.
DETROIT

TOwnsend 73000

Norwalk Bar on Conant is a prime example of the shot-and-beer type of bar that dominated Hamtramck for decades. This was one of the places where Dodge Main workers would stop to get fortified for a grueling day on the assembly line.

Hamtramckans' tastes were not limited to strong brews. Brownie pop, distributed by local favorite Atlas Beverages, was popular for decades. This distribution site is just on the other side of the Hamtramck border on Conant.

One of Hamtramck's most venerable businesses is the Kowalski sausage company on Holbrook. Founded in the back of a store in 1920 by Zygmunt Kowalski, the company remains strong today, providing a wide range of meats, including such traditional Polish favorites as kielbasa and kiszka.

Bombay Fashion on Conant is a visual demonstration of the changing ethnic nature of the city. The store caters to the growing Indian and Bangladeshi community that is moving into Hamtramck and nearby Detroit.

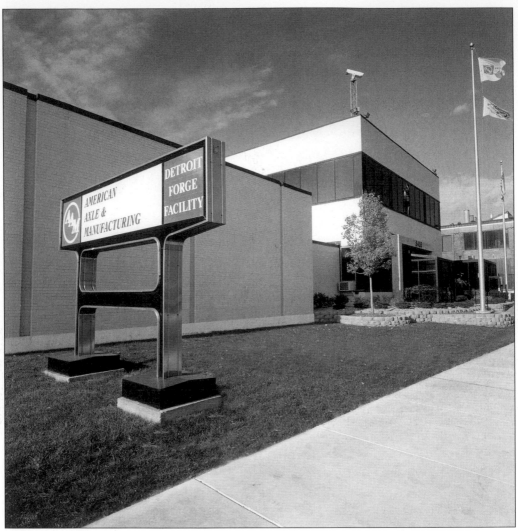

Whatever changes the business scene experiences, the city's ties to industry remain strong. American Axle & Manufacturing, formerly the Chevrolet Gear and Axle plant, remains a prime employer in town.

The powerhouse of the GM "Poletown" plant stands on land once ruled by Dodge Main. It, too, is a physical symbol of Hamtramck's long ties to industry.

The Hamtramck flag, designed by St. Ladislaus High School student Michael Balabuch, flies below the American flag. In many ways, the story of Hamtramck is the story of America. It stretches back to the Revolutionary War and encompasses all the trauma and triumphs of the immigrant influx. And above all, it survived every challenge it has faced over the years.